Mother

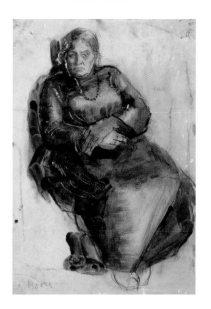

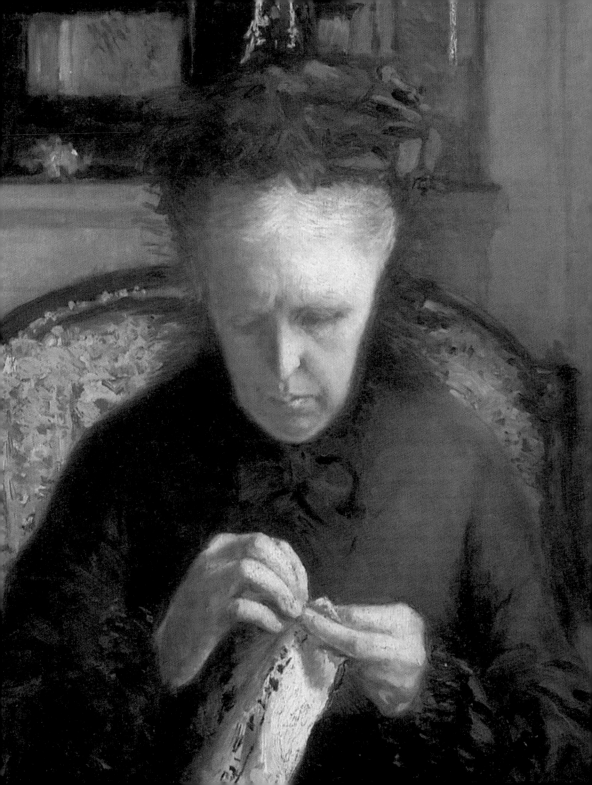

Mother

JULIET HESLEWOOD

F

FRANCES LINCOLN LIMITED
PUBLISHERS

For Mine

Frances Lincoln Ltd
4 Torriano Mews
Torriano Avenue
London NW5 2RZ
www.franceslincoln.com

Mother: Portraits by 40 Great Artists
Copyright © Frances Lincoln Ltd 2009
Text copyright © Juliet Heslewood 2009
Photographs copyright © as listed on page 95

First Frances Lincoln edition: 2009

A catalogue record for this book is available
from the British Library.

Designed by Maria Charalambous
Edited by Nicki Davis

ISBN 13: 978-0-7112-2965-5

Printed and bound in China

9 8 7 6 5 4 3 2 1

Front cover:
ERIC WILSON
Portrait of the Artist's Mother 1937
Oil on canvas, 950 x 716 mm
Canberra, National Gallery of
Australia; Purchased 1975

Back cover:
AXEL GALLEN-KALLELA
Portrait of the Artist's Mother 1896
Tempera, 330 x 290 mm
Stockholm, National Museum

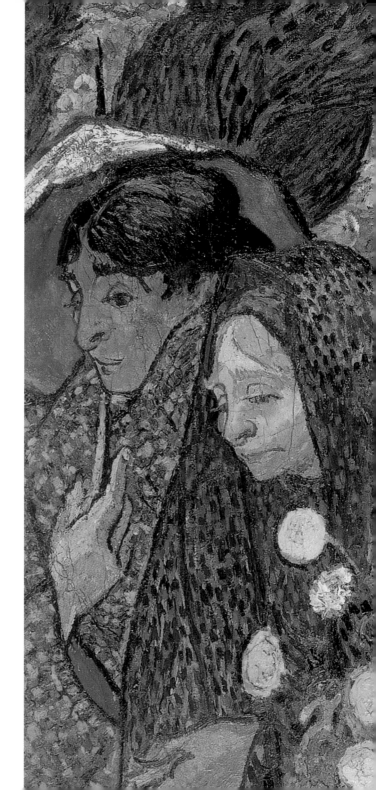

CONTENTS

INTRODUCTION

Why should an artist portray his or her mother? Because she's there, an available and willing model? Perhaps she has an interesting face, worth recording. Portraits have been painted for centuries, for many different reasons, yet mothers, as the subjects of their own children's portraits, deserve a closer look. After all, the evolution of such a picture begins with a unique and intimate relationship. Mother is not just anybody. She is the artist's mother.

Looking back over the years, there are questions that can be asked about her and the person portraying her. Was the portrait simply a result of filial affection? Did mother take her place in family portraits or, if alone, did the picture serve as a record of her looks, rather like a photograph? In portraying her, did the artist feel the need to represent not only her appearance, but also her character, her personality, which meant much to him or her? How was she dressed – in her own clothes or unusually fine or even shabby ones? Were her good looks enhanced or her bad looks improved? Was her face exactly suitable for a particular

character in a story the artist was illustrating? Who was the portrait for? Were fathers portrayed as much as mothers? It is also worth thinking about the moment in the artist's career in which she was painted. Why mother? Why then? How?

Some answers to these questions can be found by looking at each work and considering its individual history. The portraits chosen for this book are shown chronologically and the changing nature of the subject can be seen as time rolls forward over centuries to our present day.

Mothers have frequently been painted with an honest, even brutal realism. Rarely are they shown young (because of the artists' ages on taking up their brushes) but very often they are painted as older widows. The physiognomy of an elderly woman might not be what she likes to see in the mirror, but the artist, fascinated by the appearance of ageing flesh, is prepared to reveal the truth of nature's changes – even if the face belongs to his close relative. Carolus-Duran painted his

mother's face daringly close up to the picture surface. Her attractively audacious expression is softened by its framing bonnet and ties. Hockney also drew his mother's face in full close-up and like Dürer and Rembrandt before him, included every characterful line that made up the patterned surface of her skin. The ugly reality of death has also played its part in the depiction of mothers. It is with some alarm that we may imagine the artist wanting to capture the image of a mother who is in the process of dying or even dead. Cocteau, Pissarro, Ensor and Freud all drew their mothers as their lives dwindled away.

Portrait painters from Titian onwards knew that a white ruff or chemise at a sitter's neck set off the complexion. Similarly, the dress of widows' weeds (white cap with black dress) despite being the uniform of mourning, is really rather flattering. Though not idealising them, artists have frequently elevated their mothers socially, usually through the depiction of their clothes. The Russian painter, Alexey Venetsianov, made his reputation by painting

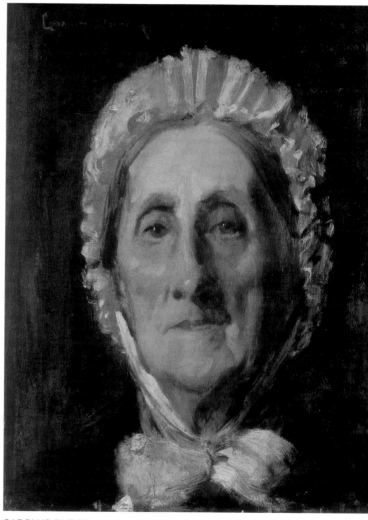

CAROLUS-DURAN
Portrait of My Mother 1876
Oil on wood panel, 419 x 340 mm
Poitiers, Musée des Beaux-Arts (on
loan from the Musée d'Orsay, Paris)

portraits of Russian peasants as well as scenes from their lives in the country. He portrayed his own mother wearing the shimmering coloured silks and pleated headdress of a woman who, through him, had reached a higher social position than the one to which she was born. Elisabeth Vigée LeBrun made countless drawings of her mother as well as her more famous sitter, Marie-Antoinette, paying particular attention to the voluminous and fancy dresses of their day. The Baroque painter, sculptor and architect Pierre Puget painted his mother in simple yet specific widow's clothes that helped to date the picture. The canvas, however, was framed in grand style, with finely carved wood and gold leaf and an inscription proudly stating that it is 'the mother of Puget, painted by her son'.

There are artists who had no intention of dressing up their mothers, but who wanted to make reference, through their clothing, to the conditions of their hard lives. Since they were not writers, able to explain at length in words the biographical background of their sitters, they could indicate much through pictorial means. Otto Dix and Mark Gertler showed their mothers wearing their everyday working clothes. The haunting expression of Gorky's mother becomes more striking thanks to the simplicity of her peasant scarf. Rooted in her domestic life, Chagall's mother, her apron tied firmly round her waist, slaves over a hot kitchen stove.

At what stage in their careers did the artists portray their mothers? Were they young, starting out, grappling with different media? Do the styles of the portraits differ from other work? If Juan Gris painted his mother as a series of intersecting flat planes in tones of beige and brown it is because he had recently come to Paris where he discovered Cubism. Mary Cassatt's mother became a favourite model who was drawn, sketched, painted in oil and in hand-applied aquatint upon etched plates as she experimented with complex printing techniques. The American sculptor Cyrus Dallin was commissioned to create large statues as public monuments and is recognised for his powerful works

PIERRE PUGET
Portrait of the Artist's Mother c.1651–5
Oil on canvas, 600 x 500 mm
Private collection

9

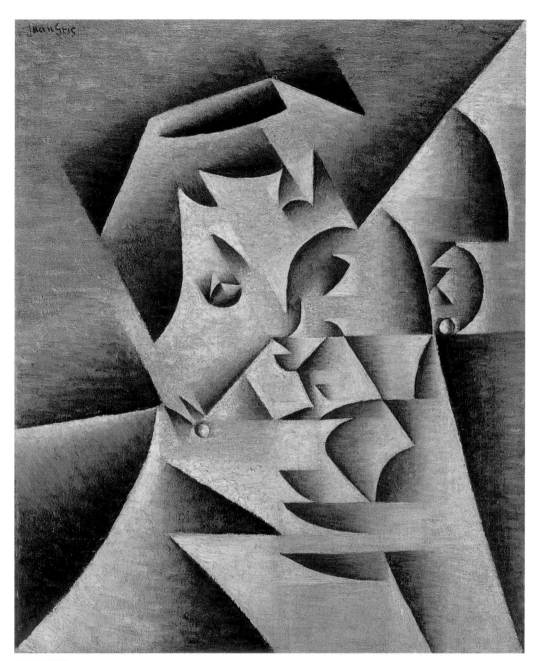

JUAN GRIS
Portrait of the Artist's Mother 1912
Oil on canvas, 550 x 460 mm
Private collection

on North American Indian themes. When it came to portraying his mother, she took her place in marble, among several finely carved portrait busts for which he was also known.

Looking at the range, it is evident that many more portraits of artists' mothers occur in works of the late nineteenth century in France than at other times elsewhere. This has much to do with the change in subject matter that evolved then and there. *La vie moderne* rather than genre, historical or moralising themes, had finally become more acceptable in the official art world. Liberated by the achievements of Impressionism, which did away with the traditional compartmentalization of subject matters, artists dared to use the domestic sphere as a source of inspiration and there she was, at home or near at hand – mother.

Family groups can be seen in Impressionist paintings time and time again and it is no surprise to find the artists' own families making frequent appearances in their work. Sometimes the artists' mothers are portrayed in their role of grandmother (Lucien Pissarro gave the titles to many of his father's works hence the mother becomes the grandmother). In his painting of his large family on a terrace, where certain members stare disarmingly at him, Bazille also included himself among them. Family gatherings are often centred upon meals. Signac composed *The Dining Room, Opus 152* in imitation of an earlier work by Caillebotte where the fine cut-glass on the table seems of more significance than the people. The woman at the end of Signac's table is probably his mother (as Caillebotte's was, sitting in the same place) but her presence is less significant than Signac's rotund grandfather or even the maid.

Portraits of mothers have occasionally been accompanied by portraits of fathers, painted at the same time and intended to hang as pendants. The theme of parents, where both are together in the same picture, is more common. Félix Vallotton painted both parents sitting, gazing intently out from the canvas at the artist (and us). The clarity of the composition, where the shapes of their dark clothing and the armchair are set against a light, neutral background, is like a forerunner of his emerging woodcut designs.

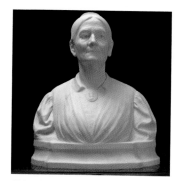

CYRUS DALLIN
Jane Dallin, The Artist's Mother 1904
Marble, 570 x 480 mm
Springville Museum of Art

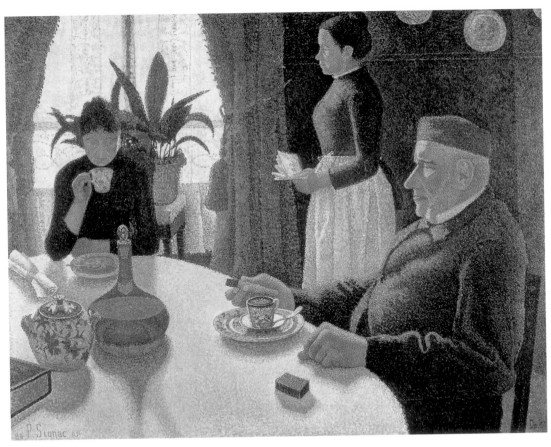

PAUL SIGNAC
The Dining Room, Opus 152 1886–7
Oil on canvas, 890 x 1150 mm
Otterlo, Kröller-Müller Museum

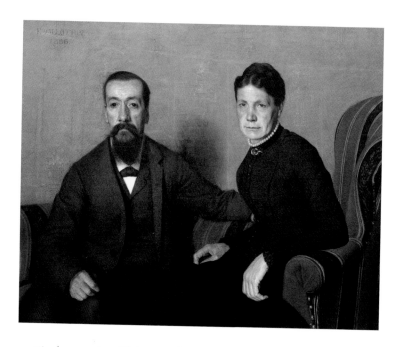

FELIX VALLOTTON
Portrait of the Artist's Parents 1886
Oil on canvas, 1020 x 1260 mm
Lausanne, Musée Cantonal des
Beaux Arts

Single portraits of fathers are far fewer than those of mothers and it would seem likely that this is indeed due to her availability. Was father out at work? Did he have less time to act as a model because of this? Or does the presence of the mother's portrait and the absence of father's hint at the relationships between them? Given the many portraits that show the mothers as widows it is obvious that father just wasn't there.

Whatever the answers to these imponderable questions, it became surprisingly clear, as I researched the subject, that those artists who painted their mothers were generally very fond of them. I had anticipated discovering all sorts of dysfunctional dynamics between them and found few. Which means that if an artist didn't really get on with their mother, they simply didn't paint her.

Juliet Heslewood

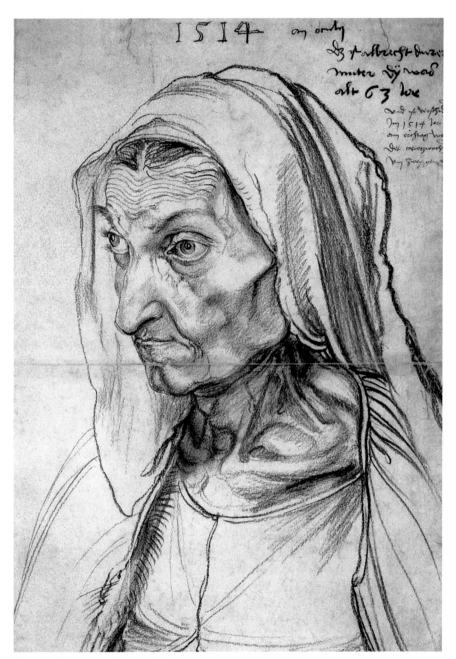

Portrait of the Artist's Mother 1514
Charcoal on paper, 420 x 300 mm
Berlin, Staatliche Museen zu Berlin;
Preussicher Kulturbesitz, Kupferstichkabinett

ALBRECHT DÜRER (1471–1528)

Barbara Dürer (née Holper)

Dürer was very young when he drew himself in silverpoint, one of the earliest self-portraits ever made. Later he added the words: 'I did this counterfeit of myself from a mirror in the year 1484 when I was still a child.' His earliest painted portrait was of his father.

Portrait painting was one aspect of his hugely successful career. He believed that portraiture 'preserves the look of people after their deaths'. The drawing of his mother was made only a few months before she died. Its stark realism reveals the hardship of her life. She was fifteen when she married and had eighteen children, only three of whom survived. It is said that when her husband suggested taking their boy Albrecht to Venice, since he was keen to be an artist, she feared the sky might fall down on him.

The drawing reveals two aspects of Dürer's extraordinary talent – his ability to meticulously record what he observed and the assurance of his linear drawing style. His excellence in the art of woodcut design and all aspects of engraving can account for this. His drawing depicts, with great clarity, his mother's physiognomy – the bony, almost emaciated face and the musculature of her neck, her firmly closed mouth, deep lines across her forehead, the thinning skin beneath her staring, unequal eyes. It is a profoundly moving if startling image. Dürer said that 'even the smallest wrinkles and veins must not be ignored'. Yet in other works he showed an interest in the depiction of ideal beauty, based on classical examples, that his contemporary artists in Italy were painting.

Dürer wrote a chronicle of his family and this fascination for recording facts can be seen in the later writing on his mother's portrait. He precisely refers to the third Sunday in Lent, 19th March: 'This is Albrecht Dürer's mother when she was 63 years old.' Separated from this is added, 'and she passed away in the year 1514 on Tuesday before Rogation Week, about two hours before nightfall.' It is as if, through recording these facts, he turns the vivid drawing into a certificate or document.

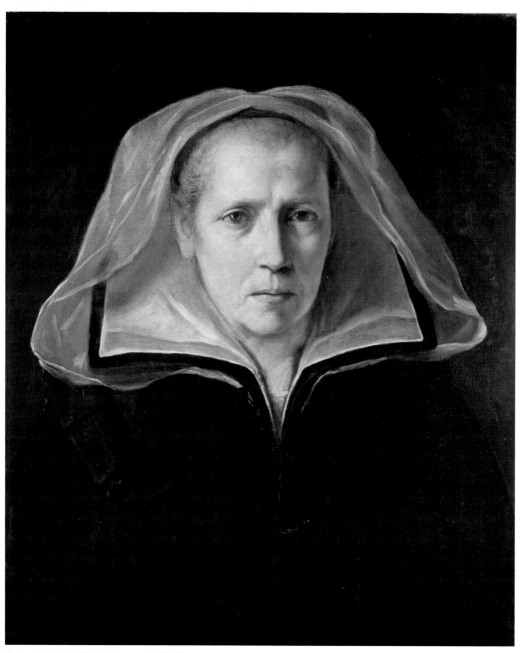

Portrait of the Artist's Mother c.1615–20
Oil on canvas, 640 x 550 mm
Bologna, Pinacoteca Nazionale

GUIDO RENI (1575–1642)

Ginevra Pozzi

Hailed as one of the greatest, most influential Italian painters of the seventeenth century, Reni's religious works appealed through their refined sense of beauty and grace and were in demand as images of devotion to hang in the Vatican itself. 'I would have liked to have had an angelic brush and forms from Paradise in order to design the Archangel and to see it in heaven; but I could not ascend so high and in vain I sought it on earth,' he said, describing painting St Michael. For his beautiful Madonnas and Magdalenes, at times shown in states of divine ecstasy, he said 'it is necessary to have the concepts of beauty here in the head, and then any model will do.'

The portrait of his mother is far from an imaginary vision of ideal beauty. Her face, with its serious, penetrating gaze, peers from darkness, surrounded by the pale, delicate folds of her widow's headdress. She was widowed twice and, being very close to her, Reni took her with him when he moved to Rome in 1627 to paint in the loggia of St Peter's.

Always he had supported her in lavish style, as can be seen from his account books. He once bought her a fine carriage (a great luxury at the time) but was obliged to sell it when he saw how little she used it. In Rome he settled her into a house near his studio where he worked all day, returning to be with her to eat and sleep at night.

She died in February 1630 and it has been suggested that the painting dates from this time. Certainly after her death Reni began to gamble recklessly and to distance himself from women in general, becoming 'like marble' in their presence. He was angry when one servant even touched his laundry. His biographer, a contemporary, claimed 'one never smelled a bad odour coming from his body, although since he lived, at the end, especially after the death of his beloved mother, without any women in his service, he was not waited on with the polished cleanliness that is characteristic of them.'

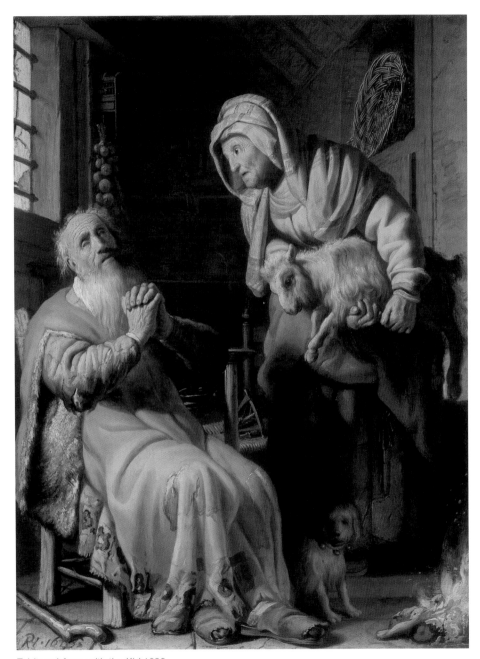

Tobit and Anna with the Kid 1626
Oil on Panel, 395 x 300 mm
Amsterdam, Rijksmuseum

REMBRANDT VAN RIJN (1606–69)

Neeltje Willllemsdr. Rembrandt (née van Zuytbrouck)

Rembrandt was born into the bakery business – on both sides of his family. His father was joint owner of a 'mill on the Rhine' (the derivation of the name Rembrandt) and his mother was the daughter of a baker. His parents gave him a good education so that he might have great prospects and they hoped he would go to the recently founded University in Leiden, the town where they lived. Instead he studied under reputable history painters and eventually set himself up in Leiden as an independent artist.

Religious painting and portraits were the two major themes of Rembrandt's career. Both his parents were converts to Calvinism before their marriage and in his biblical narrative scenes Rembrandt was able to infuse his canvasses with deep, spiritual feeling. In this early painting he combined drama with realism to illustrate a story from the *Apocrypha* where the innocent Anna has been accused of stealing a kid by her blind husband, Tobit. Both characters show great emotional alarm within their warm, domestic environment.

As a young man Rembrandt painted his own face, continuing throughout his life to examine its changing appearance. In this picture, the face of Anna is virtually identical to many other faces that appear in Rembrandt's early paintings as well as in etchings and a drawing. This face is generally accepted to be that of his mother who died in 1640 aged seventy-two having been a widow for ten years. Whether he was painting his own face or hers, Rembrandt revealed his extraordinary ability to understand the nature of paint and to manipulate it for his particular needs. He built up paint in layer upon layer, dragging the brush or a palette knife over its surface in order to imitate real flesh. Painting old skin realistically was one thing, but to suggest the knowledge that accompanies old age is another and Rembrandt excelled in both. The old woman whose face appears while she acts a part, reads, prays or is simply seated was certainly a permanent inspiration to him.

An Old Woman at Prayer c.1629–30
Oil on copper, 155 x 122 mm
Salzburg, Salzburger Landessammlungen-
Residenzgalerie

*Madame Rigaud, Mother of the Artist in
Two Different Positions* 1695
Oil on canvas, 830 x 1030 mm
Paris, Musée du Louvre

HYACINTHE RIGAUD (1659–1743)

Marie Serre

Hyacinthe Rigaud was determined to become the most significant portrait painter of his day. After years studying in the south he moved to Paris and opened his own studio while taking drawing classes at the Académie Royale. Though he won the prestigious Prix de Rome, he was advised not to take up its scholarship and travel to Italy, but to concentrate on his developing career. Eventually he reached the French Court and gained wide recognition with a large canvas of Louis XIV. He was soon in demand from some of the leading royal families in Europe.

In 1695 Rigaud travelled south to Perpignan to visit his mother, of whom he was very fond. Since becoming a widow prematurely, she had devoted herself to her son's career. He created an image showing her in profile and in three-quarter view. This was not entirely unusual. Van Dyck, painter to the English Court whom Rigaud admired, had done a triple view of Charles I that had been used by Bernini, the Italian sculptor, for a portrait bust. Rigaud must have had the same idea in mind when he asked his friend, Antoine Coysevox, the court sculptor, to make a bust of his mother. The two highly finished painted images present alternative angles and the marble bust, being in the round, would have multiple views of her head. Rigaud also painted variations on her Catalan costume – so different from the fantastic dress of the court. The headdresses are recognisably of silk or velvet and the fine, pale drapery of her chemise finishes in a dainty collar or shawl-like folds. Though busts of unknown women were rare, Coysevox had plenty of information to begin carving and his work was realised eleven years later.

This realistic portrait shows Rigaud's ability to observe yet dignify his sitter by traditional means – lighting her from a single source and placing her against a picturesque ruin in a dark background, suggestive of an evening, rural scene. Rigaud left his portrait to the Académie Royale where, in 1733, he had become its director.

The Artist and His Family 1760
Oil on canvas, 1200 x 1000 mm
Arles, Musée des Beaux-Arts

ANTOINE RASPAL (1738–1811)

Claire Raspal (née Dedieu)

This charming painting is considered a reliable source for the appearance of women's costumes in Arles before the French Revolution. It shows the artist Raspal happy and relaxed at work, accompanied by his mother and younger sister Marie as well as his older sister, Catherine, whose portrait he is painting.

Raspal's mother was the daughter of a sculptor in Arles and the niece of Jean Dedieu, sculptor to the King who worked in the gardens at Versailles and on the rood screen at Chartres. Twice in his life Raspal worked in Paris, but he returned to his home town to paint many themes including interiors. These were painted with an attention to detail similar to Chardin. He also made portraits of Arles' aristocratic and middle class society. One of his paintings shows a busy dressmaker's workshop. In popular history Arles is remembered for the beauty of its women, the Arlésiennes, and for their attractive traditional dress.

Here, though his keen eye observes the characterful women's faces, their clothing also becomes a major part of the group portrait.

He wears neatly-buttoned and bright red trousers that create a base to the painting's composition. The same red springs up in his cheeks and amiable smile and in the women's exquisite clothes. Each wears a diaphanous headdress in the 'canoness' style. Round their necks are enamel Maltese crosses on thin black velvet ribbon. The mother's cross has one heart-shaped piece. Mme Claire's silk bodice is more subdued in colour than her daughters' pastel shades and is reminiscent of Indian designs which formed the origin of traditional Provençal patterns. Skirts and sleeves each have fine floral motifs with embroidered edges. The girls' muslin shawls are pinned at their bosoms with fresh blooms of rose and lilac. Behind the family the wall's sober, striped design sets off the pretty lightness of the clothes.

Mme Raspal left her 'silk and taffeta dresses' to one of her daughters, an indication of their value and her own affection for them. She never could have guessed that her son's portrait would give them a life that endured far longer than the wishes of her will.

Ann Constable 1804
Oil on canvas, 760 x 635 mm
Colchester, Castle Museum

JOHN CONSTABLE (1776–1837)

Ann Constable
(née Watts)

Ann Watts married three days before her nineteenth birthday. She left London for Suffolk where her husband, Golding Constable, had inherited much land and where he later bought two watermills and built a house. Once she began her family of six children, Ann devoted all her attention to them and was remembered for her frugality, piety and domestic virtues. When their son John was older, both parents hoped he would take over as head of the flour mills. In 1799 John went to London to pursue his career as an artist. Ann frequently wrote to him, sending him money to travel home again, which he often did, bringing back his laundry for her to wash!

Ann believed John might succeed as a portrait painter. Only recently the first President of the Royal Academy, Sir Joshua Reynolds, had died. In one of his *Discourses* to students, he had said 'the excellence of Portrait-Painting, and we may add even the likeness, the character and countenance … depend more upon the general effect produced by the painter, than on the exact expression of the peculiarities, or minute discrimination of the parts.' Painting his mother, Constable showed her in an informal role, sitting in an upright chair, a dog upon her knee. Her facial features, her fringe of hair and the details of her bonnet are far from an attempt at generalisation that Reynolds had advised. This was no grand, public portrait – it was the image of a loving, close relative. In a copy of the painting she is shown facing the other way, the image reversed, probably to match an existing portrait of her husband, making them a pair.

Ann had always encouraged John saying 'you must try hard for fame and gain'. When she wrote to him, though a devoted mother, Ann's practical streak shone through her words. 'Whilst we are on this earth,' she said, 'our plans and ideas must be worldly.'

Eventually, he established his reputation as a painter of his home countryside. 'The sound of water escaping from mill-dams,' he wrote, 'willows, old rotten planks, slimy posts and brickwork, I love such things.'

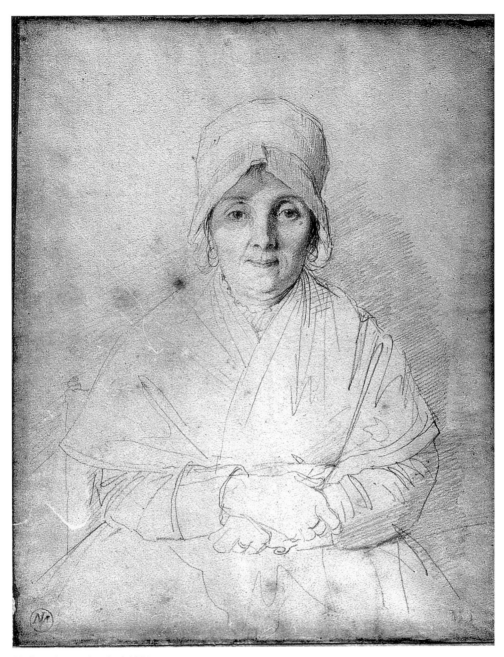

Madame Ingres (mother) 1814
Pencil on paper, 200 x 150 mm
Montauban, Musée Ingres

JEAN AUGUSTE DOMINIQUE INGRES (1780–1867)

Anne Ingres
(née Moulet)

At a young age, in 1801, Ingres won the prestigious Prix de Rome with its great promise of future success and a spell in Rome to study. He did not leave until 1806, when the Académie's funds were available. He delayed further by submitting five portraits to the Salon, the official showplace where artists gained recognition. Since these were badly reviewed he resolved to prove himself once he was settled in the Villa Medici.

Portraits were greatly in demand in Rome, especially among travellers journeying through Europe on the Grand Tour. Yet Ingres, who was to become so renowned for his portraiture, believed in the traditional subject matter of his time. He preferred painting historical scenes or themes of noble deeds. When someone came to his door asking if 'the man who drew those little portraits' lived there, Ingres replied, 'It is a painter who lives here.'

While in Rome, Ingres' father died. His mother wrote him a long, moving letter. In it she said how fine it would be to join him although it would mean leaving his two sisters behind. 'I hardly dare think I would have the courage. However, the idea of seeing you again, to hold you close to my heart; to see you delight in the most tender union of perfect felicity, the greatest of all feelings, to see you happy and myself, seeing the pleasure of such a scene', she wrote ecstatically, her grammar confused, as if breathlessly talking, 'is the most inviting painting that my imagination could invent.'

Anne Ingres did go to Rome where her son, nicknamed 'Ingrou', drew the delightful portrait of her – one of his most appealing in its fresh simplicity and directness. Her hands and clothing are summarily drawn while her head receives all the attention of his dexterous pencil work. Shade delicately falls beneath her bonnet *à la Gasconne* and over her right eye. Her mouth is pursed and smiling. Ingres held on to the drawing once she had returned to France, keeping it as a memento of her face and of her short stay with him.

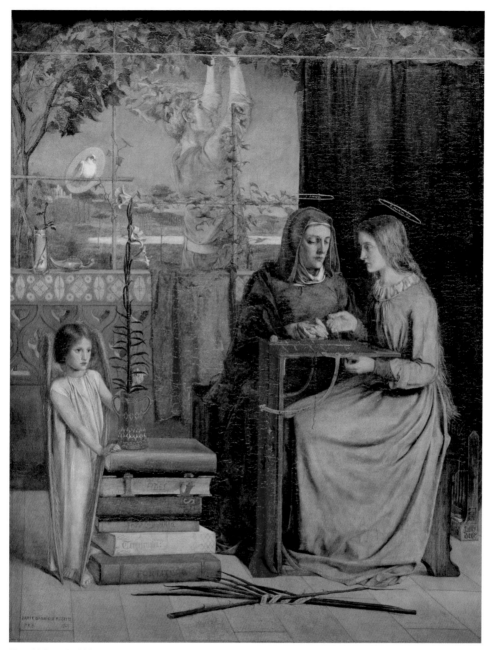

The Girlhood of Mary Virgin 1848–9
Oil on canvas, 832 x 654 mm
London, Tate Gallery

DANTE GABRIEL ROSSETTI
(1828–82)

Frances Rossetti
(née Polidori)

Familiarity with books in her childhood helped Frances Polidori choose teaching as a profession when she was older. Unlike many single Victorian women, Frances did not see the role of governess as demeaning. At one time an employer's brother offered her marriage and the prospect of a comfortable life with no need to work. But she loved to communicate her learning and was able to teach and earn an income on marrying Gabriele Rossetti, a penniless Italian who, like her own father, came to England as a political exile.

Frances was brought up as an Anglican and her parents, of different religions, refused to change their individual beliefs. They raised their sons as Catholics and their daughters as Protestants. Religion was always of profound importance in her life and the fact that all her own children were raised as Protestants shows the strength of her belief as well as her character.

She refused the help of nannies for her children, giving them not only great affection as well as measured discipline, but also a craving for intellectual and creative pursuits. 'If a man has any poetry in him he should paint,' her son Gabriel declared and both he and his sister Christina wrote poetry.

As art students at the Royal Academy, Gabriel and his friends sought to overthrow conventional teaching methods. They believed contemporary art should be more restrained, with a moral message and painted in fresh, bright colours – like the art of fifteenth century Italy, before Raphael. They called themselves the Pre-Raphaelite Brotherhood. Gabriel also adopted the name of the medieval Italian poet, Dante.

For centuries religious paintings contained ideal looking characters. In order to lend their work an authentic, realistic feel the Pre-Raphaelites used models who were known to them. Here Rossetti used his mother for St Anne and his sister Christina for Mary. Frances is shown in both her naturally acquired roles of mother and teacher. On the day Frances Rossetti died, having outlived Dante Gabriel, Christina wrote that she felt herself to be the 'happy and unhappy daughter of so dear a saint.'

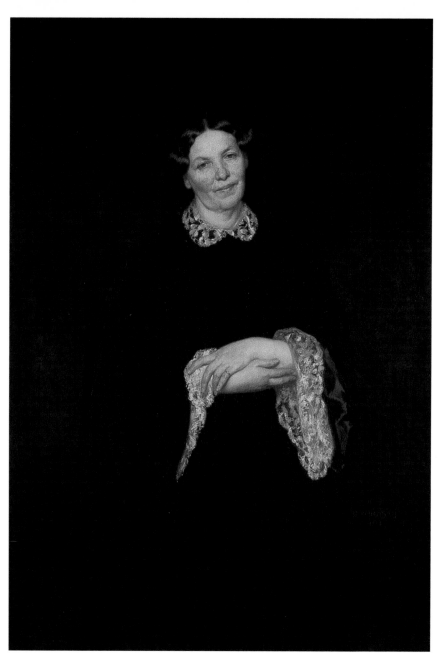

Portrait of the Artist's Mother 1853
Oil on canvas, 1340 x 950 mm
Lodz, Muzeum Sztuki

HENRYK RODAKOWSKI (1823–94)

Maria Rodakowska

In the mid-nineteenth century Henryk Rodakowski was hailed as one of the greatest artists living and working in Paris. He was Polish and had studied in Vienna. His early works were watercolour portraits. An oil self-portrait showed the promise of a style that was bound to appeal to Parisian high society. His contemporaries had much to say about him. When comparing his highly finished work with that of the celebrated master Leon Bonnat, the latter's was described as 'having been done in plaster with a mason's trowel'.

Though, like Ingres, he wanted to paint epic, narrative work, especially themes relating to Polish history, it was in portraiture that he excelled and established a successful career. However, even in large history paintings, his ability to create characterful details allowed his imagined personalities to appear true portraits.

The beautiful portrait of his mother gained a deserved accolade at the Salon of 1853. Delacroix called it a masterpiece – praise indeed from one of the most revered of French artists. The appealing image of the pale, smiling face looming out of a dark background, her neck circled by a lacy collar is repeated in the posed, yet equally fine pair of hands and lace cuffs.

Rodakowski left Paris in 1867. On the death of his mother one friend wrote to him 'I was not able to accompany you yesterday with the body of your mother to her last home, but today I will go to a mass for her and pray from the depths of my heart for her soul's rest.'

Thirty years after the portrait was painted and Rodakowski was less secure in his career, he received from a friend a kind reminder of the painting's great reputation: 'Don't worry too much about your fate, dear friend … . It is the quality and not the quantity of work that is important. The portrait of Dembinski and the one of your mother are of the first order and save your name from being forgotten. That's the best way to survive and you've done it.'

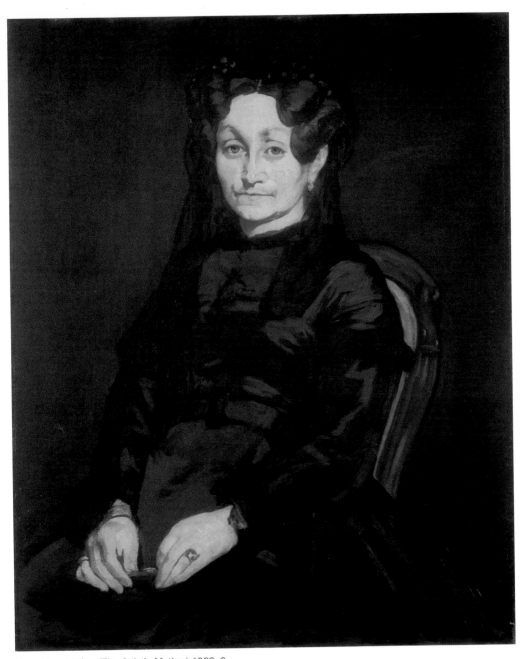

Mme Manet Mère (The Artist's Mother) 1863–6
Oil on canvas, 980 x 800 mm
Boston, Isabella Stewart Gardner Museum

EDOUARD MANET (1832–83)

Eugénie Désirée Manet (née Fournier)

Manet's distinguished parents made a formidable alliance when they married. His father became a judge in the Ministry of Justice and was later awarded the Legion of Honour. His mother was the daughter of the vice-consul of France in Sweden and goddaughter of the Crown Prince of the Royal House of Sweden from whom they received generous wedding gifts. Living in Paris, Mme Manet was able to rule over her own celebrated salons where women friends were received on Tuesdays and her sons' friends on Thursday evenings. Their dazzling social life was changed, however, when her husband was suddenly stricken with paralysis, limiting both his movement and his speech and he was forced to retire.

The portrait of his mother alone is worth comparing with the one Manet painted when both parents were alive. In the single portrait Mme Manet assumes a forceful and penetrating stare out of the picture at the spectator. She is shown in a seated pose, hands on her lap, not dissimilar to other such portraits of mothers as widows dressed in black.

This is the clothing of official mourning yet black, as a colour, was almost a favourite of Manet's. He greatly admired Spanish painting where black was a characteristic feature.

In the double portrait of his parents this preference for black and its effective use in contrast to white or paler skin tones is evident. The concerned expression on Mme Manet's face can be understood when we know of her husband's condition that had struck some two years earlier. At that time she had written to the Justice Minister mentioning 'the expression of sadness which is painted on his face'. Rather than draw attention to his sorry state, Manet showed his father staring downwards, like his mother, as if both were engaged in some significant reflective occupation. 'I posed them in the most straightforward way,' he said. After her husband's death, Mme Manet rarely accepted social invitations. She herself was paralyzed following a stroke less than three months after Manet's own death.

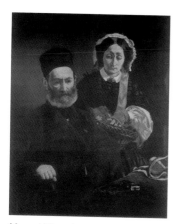

M. and Mme Auguste Manet 1860
Oil on canvas, 1115 x 910 mm
Paris, Musée d'Orsay

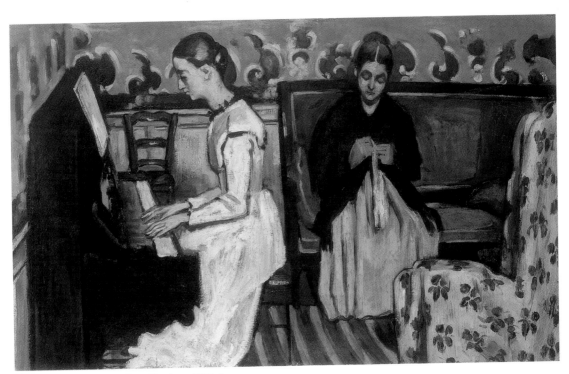

Girl at the Piano. Tannhaüser Overture 1868–9
Oil on canvas, 570 x 920 mm
St Petersburg, State Hermitage Museum

PAUL CEZANNE (1839–1906)

Elizabeth Cézanne (née Aubert)

Elizabeth Aubert gave birth to a boy, Paul, and his sister, Marie, before marrying their father, Louis-Auguste Cézanne. Soon afterwards she went to live above his hat shop in the centre of Aix-en-Provence. Another sister was born later but it was Marie, who, remembering their mother, said how Paul had 'loved her dearly and was no doubt less afraid of her than of our father who was not a tyrant but was unable to understand anyone except people who worked in order to get rich.'

Cézanne painted few portraits of people other than those very close to him. This painting shows their home, the Jas de Bouffan, where the family moved after their father became a successful banker. The title refers to Wagner's overture that was first played in Paris in 1860 and was hailed by Baudelaire as being 'voluptuous and orgiastic'. Little of the Romantic nature of the music is evoked in this subdued, still scene. Marie plays the piano and it is thought that their father sat in the armchair opposite Elizabeth,

but that he was painted out.

Elizabeth always believed Cézanne would succeed as a painter although his father doubted any success financially. For a while she kept it secret that their son had a mistress, with their grandchild living in a house nearby, though later they married. At their father's death, Cézanne and his sisters inherited his wealth leaving him free to devote the greater part of the rest of his life to tirelessly painting the landscape around Aix. The painter Emile Bernard wrote many memories of his visits to Cézanne and said: 'The day of his mother's funeral, he could not follow the procession because he had to go to paint. And yet, no one had loved her or wept for her more than he.'

An early portrait of Marie exists. When it was sent for conservation the image of a woman in a white scarf was found on the back. Though described as a 'peasant woman', it is believed to be another representation of Cézanne's mother.

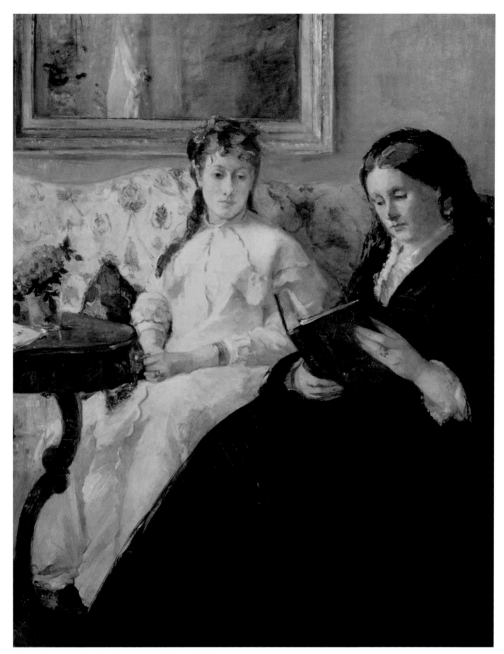

Portrait of the Artist's Mother and Sister 1869–70
Oil on canvas, 1010 x 818 mm
Washington DC, National Gallery of Art

BERTHE MORISOT (1841–95)

Marie-Joséphine-Cornélie Morisot (née Thomas)

Berthe Morisot, rebellious by nature, was determined to triumph as a painter, a profession dominated by male achievements and prejudices. Berthe's parents were respectable, upper middle class Parisians. Her mother had wanted to be a musician but in cultivating a dazzling social life saw her personal ambitions channelled through her children. Politics and art were discussed at the Morisots' on Tuesday evenings while on other days the lively home was open to friends at tea time.

By the time they were adults, Berthe and her sister had become promising artists. Mme Morisot carefully followed their training, attending their lessons, sitting apart as she embroidered. When in the Louvre copying the Old Masters they met the artist Fantin-Latour and through him, Edouard Manet. Fortunately Mme Morisot's social evenings did not coincide with those of the Manets on Thursdays. Berthe became Manet's model, close friend and eventually his sister-in-law.

Her quintessentially Impressionist style, with its fresh, pastel colour schemes and light brush strokes bears comparison with Manet's. Despite their closeness she had no intention of succeeding other than through her own merit.

The painting of her sister Edma with their mother reading to her is a typical contemporary family subject that the group favoured. She decided to send it to the Salon, the annual exhibition where artists sought official recognition. On passing their home and finding her preoccupied with the painting, Manet dared to retouch it – inciting Berthe's fury. 'He laughs like an idiot, hands me the palette, takes it back again,' she told her sister. 'My only hope is that it will be rejected. Mother considers the whole thing amusing, but I find it most annoying.'

Mme Morisot also described the scene. 'Berthe tells me that she would prefer to be at the bottom of a river than learn that it has been accepted,' she said. 'The least little thing takes on tragic proportions.'

Her mother's calm reassurance helped Berthe gain the recognition she deserved. She turned her back on the Salon, exhibiting at each Impressionist show except when she was ill following the birth of her daughter, Julie Manet, who, following Edma, was to become her favorite model.

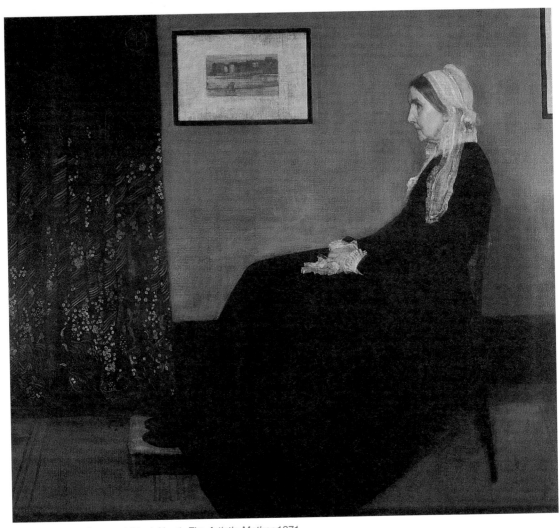

Arrangement in Grey and Black No. 1: The Artist's Mother 1871
Oil on canvas, 1443 x 1625 mm
Paris, Musée du Louvre

JAMES MCNEILL WHISTLER
(1834–1903)

Anna Mathilda Whistler (née McNeill)

This most famous of all artists' mothers came to pose for her portrait almost by accident. Whistler had been expecting a model for another painting and when she failed to turn up he suggested to his mother that he painted her. It was in a dark room at the back of his Chelsea house that Mrs Whistler stood for a few days but, finding this uncomfortable (she was sixty-seven) she preferred to sit down for the portrait. Her position, parallel to the wall and to the surface of the canvas, is as carefully calculated as each of the few elements in the painting, with horizontals and verticals emphasised. Areas such as the curtain and the picture were originally further to the right and the figure itself raised. Finally, Mrs Whistler appeared posing obediently, calm and still, staring ahead from her own self-contained space. The title suggests a piece of music and Whistler intended it to be a harmony – of subdued colouring. The fine notes of white reach out as bright chords from the more dim areas of grey and contrasting black.

Whistler at first had great difficulty with the painting but his mother was later able to describe its progress in a letter to her sister: 'I observed his trying again, and oh my grateful rejoicing in spirit as suddenly my dear Son would exclaim, "Oh Mother, it is mastered, it is beautiful!" and he would kiss me for it!'

Mrs Whistler is seen in the black mourning clothes she wore once her husband, a railway engineer, died. The artist had spent part of his childhood in Russia and some time back in the family's native America before studying in Paris. Here, like many of his contemporaries, he responded to the influence of Japanese art which had arrived in the West revealing different ways of representing the world. In London Whistler furnished his home with a distinctive oriental flair. It was in Chelsea that his mother joined him, ousting his mistress from the home, settling to a sober life compatible with her strict religious beliefs.

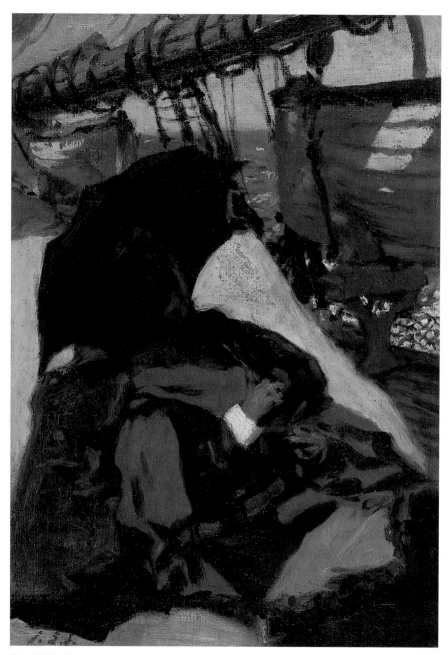

The Artist's Mother Aboard Ship 1876
Oil on canvas, 280 x 197 mm
Private collection

JOHN SINGER SARGENT
(1856–1925)

Mary Newbold Singer (Mrs Fitzwilliam Sargent)

Sargent's mother was a compulsive tourist. When her father died, leaving her an inheritance, she persuaded her husband, a doctor, to give up his practice in Philadelphia and live in Europe. Not wanting to settle down, she and her family joined ex-patriot communities in the warmer towns of Nice, Florence and Rome in winter while in the spring they moved further north.

Sargent grew up speaking Italian, French and German. Another feature of his travelling childhood was his mother's encouragement in sketching the places where they stayed. When they were not walking or sight-seeing she would guide her children round the more reputable European museums. Sargent grew up loving paint. To become a professional he needed formal training beyond what he had learned in European galleries. In 1874 he joined the prestigious studio of Carolus-Duran at the time when the First Impressionist Exhibition burst upon a shocked Parisian public. His early painting of his master won him a medal at the Salon and launched his career as a portraitist.

Sargent's great appeal was in his lively representations of the elegant people of his day. These are often full-length poses in interiors with sitters appearing relaxed and almost unnaturally pleased with themselves. Many contemporary artists and critics found his portraits very superficial, without great insight.

His mother, to whom he remained close, was also the subject of several portraits but in his painting of her on board ship, although her face is in shadow, he has managed to capture an image of her in a situation she knew very well – in transit. The bold contrasts of light and shade and the visible, strong strokes that appear in this sun-filled setting are similar to early Impressionist paintings of the same date.

Sargent's mother died in 1906 after he had cared and provided for her for years. 'She is believed to have been the dominant force in the family', he said, 'and to have obtained everything she really wanted.' To see him succeed as an artist known throughout Europe was one of her most treasured ambitions.

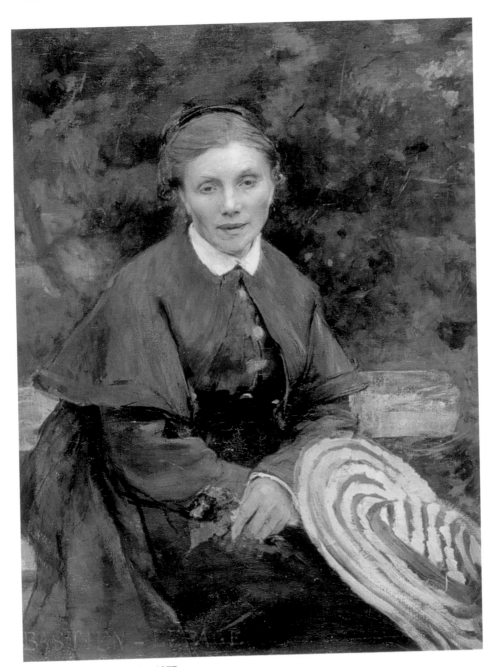

Portrait of the Artist's Mother 1877
Oil on canvas, 1030 x 770 mm
Nice, Musée des Beaux Arts Jules Cheret
(on loan from the Musée d'Orsay, Paris)

JULES BASTIEN-LEPAGE (1848–84)

Catherine Adèle Bastien (née Lepage)

The painter took both of his parents' surnames. He was born on a farm, his father's family, the Bastiens, being peasant landowners. The more urban Lepages, on his mother's side, hoped he would have an adminstrative career. Neither parent was happy when he took up painting but to please them, while studying in Paris, he found a job as a postal clerk.

He developed a style of painting that owed more to the Realists than to Impressionism and his admiration for Courbet is shown in his choice of rural subject matter, especially the people who worked on the land. His attitude was not only to illustrate the truth of country life, but to bring to it a freshness and naturalism. 'I want to do reality and if I can, make it poetic,' he said.

At the Salon of 1877, artists could enter no more than two portraits. Bastien-Lepage wanted to show three, so attached the portrait of his mother to one of his father, retouching background details to make them appear as a single unit.

The even tone of the painting was criticised as being dull, sad and unhappy. His mother sits in a pale, opaque, northern light that characterises much of his outdoor work and was largely due to his knowledge of advances made in photography.

In his early thirties Bastien-Lepage developed stomach cancer yet planned much more work, based on peasant themes relating to childhood memories. When a doctor advised travel and a change of air, his mother accompanied him to Algeria where he was greatly impressed by the sea, the desert and village life. Returning to Paris, she cared for him and the night he died they chatted about their old home. It was here, at Damvillers in the Meuse, that his body was finally buried. A photo exists of his mother placing a bouquet on his grave. In homage to the artist, his friend, the sculptor Rodin, created a life-size bronze statue of him. This crowned a later family tomb where his mother, when she died, was also buried.

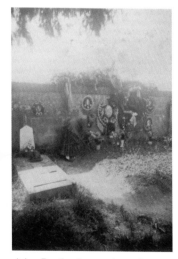

Jules Bastien-Lepage's mother adding a bouquet to his tomb in the Damvillers cemetery c. 1889
Private collection

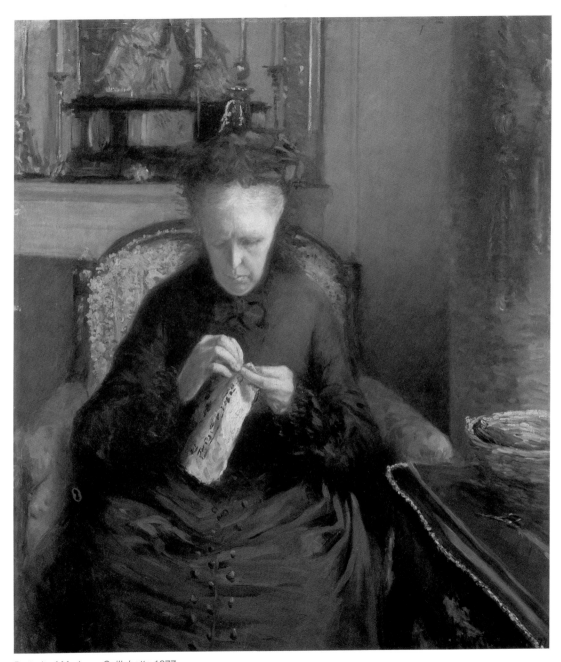

Portrait of Madame Caillebotte 1877
Oil on canvas, 830 x 720 mm
Private collection

GUSTAVE CAILLEBOTTE (1848–94)

Celeste Caillebotte (née Daufresne)

Caillebotte's parents were both from well-to-do backgrounds, his mother the daughter of a lawyer. The family had a series of homes that boasted grand addresses, including an elegant country house with a park and river frontage in Yerres, outside Paris. When his father died in 1874 Caillebotte was left to share a fortune with his mother and siblings. Their comfortable life was often the subject of his paintings.

Mme Caillebotte enjoyed embroidery and was particularly talented at the craft. Her son, the artist, created specific designs for her. In his representations of family gatherings, her embroidery frame is sometimes shown near at hand. Caillebotte's ability to describe the social milieu he was born into is realised through his attention to such detail and informs us about the pastimes his mother and other family members enjoyed.

The portrait of his mother shows her in her Parisian home, sitting, concentrating as she sews. The interior is furnished with all the lavish trappings of the bourgeoisie – red velvet, gilt, black marble, candelabra, bronze – materials that contrast with the austerity of her mourning clothes (one son had recently died) and the simplicity of her basket and scissors. With this and other works Caillebotte was able to present a family trilogy which he exhibited in 1876 including a theme popular with the Impressionists, a luncheon, where his mother sits at the distant end of a table laid with finest crystal and silver – more like a large still life than a family scene.

Embroidery, for art critics, was a metaphor for the demands and painstaking work required by acceptable artists – which the Impressionists, in their opinion, had ignored. At the second Impressionist exhibition one critic claimed that sewing things up was too difficult a task for intransigents such as them and that their blurred paintings were hardly more than sketches. From early in their careers, Caillebotte was able to buy the work of his friends. At his early death he was determined to leave his collection to the state and it now forms the core of the Impressionists' work at the Musée d'Orsay.

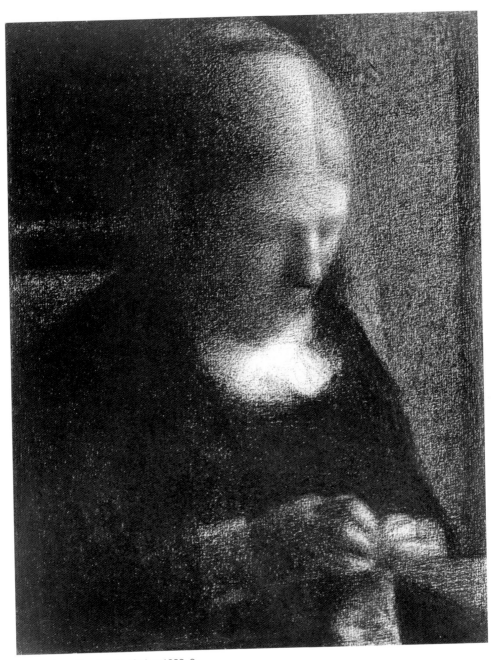

Embroidery; The Artist's Mother 1882–3
Conté crayon on paper, 312 x 241 mm
New York, The Metropolitan Museum of Art

GEORGES SEURAT (1859–91)

Ernestine Seurat
(née Faivre)

Seurat was an introverted young man, committed to his work and very silent about his personal life. He was devoted to his mother and dined with her each day even when he had a secret mistress living with him less than a kilometre away. Mme Seurat was good company, interested not only in her son's work but in much contemporary art. She commissioned a painting from the Impressionist Pissarro.

Seurat is associated with the Pointillist (or Divisionist) technique that evolved from Impressionism. Scientific theories developed before his time enabled him and his contemporaries to explore new possibilities in the representation of their world. Paint was not necessarily mixed on a palette but placed directly from the tube onto the canvas – in tiny dots. The eye, looking at the painting from a distance, then did the mixing.

Though his painted figures and objects appear static because of the limited freedom of this technique, Seurat's drawings are much softer. He used conté crayon, which resembles charcoal, on paper that had a thick, uneven surface.

He drew his mother often and in this portrait the blurred edges of her hairline, chin and facial features merge into an indistinct background. Her hands are not sharply defined. Black contrasts boldly with white, yet the whole shadowy image achieves a calm dignity. The paper's grainy texture either catches the finely applied crayon, or misses it and the surface appears as if covered with dots.

The portrait was refused at the 1883 Salon yet the critic Roger Marx said of another accepted drawing that it was 'an excellent study in chiaroscuro, a drawing of merit, which cannot be the work of a nonentity.'

Seurat's mother tried to establish a reputation for her son's work after he died at her home at a very young age. She had kept letters, reviews and a variety of papers received from owners of his work, expressing their appreciation of it. Today it is understood that despite his short career, he had led and encouraged changes in the technical approach to painting that would have far-reaching effects right through into the twentieth century.

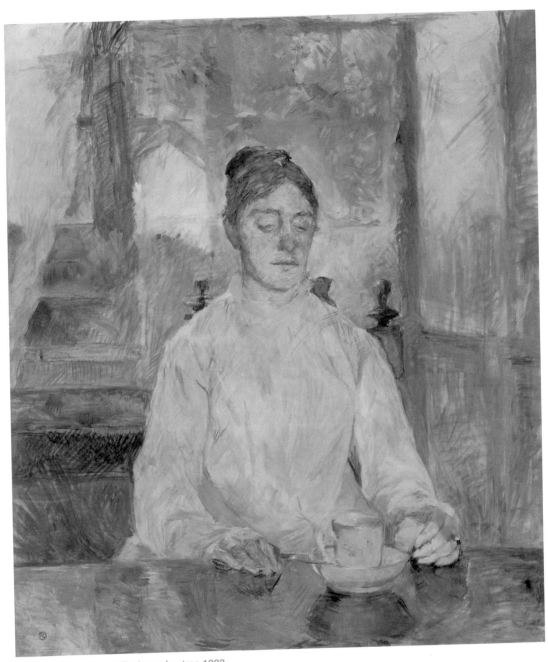

Countess Alphonse de Toulouse-Lautrec 1883
Oil on canvas, 935 x 810 mm
Albi, Musée de Toulouse-Lautrec

HENRI DE TOULOUSE-LAUTREC
(1864–1901)

Countess Alphonse de Toulouse-Lautrec
(née Adèle Zoë Tapié de Céleyran)

The two grandmothers of the artist were sisters. His father inherited his title that went back to the Counts of Toulouse in medieval times when they had been powerful landowners in the south-west of France. His mother's family owned a château and vineyards nearer the Mediterranean. His parents' match, between first cousins, was, according to his father, the 'impetuosity of impulse' and greatly responsible for their son developing severe physical disabilities. As the marriage became strained, with Alphonse frequently hunting away from their château near Albi, Adèle turned her attention towards her religion and the care of their unfortunate boy. Henri, though restricted from sporting activites, found great rewards in drawing and painting. Later, since he did not need to earn a living, it was with some alarm that his parents saw him settling down in Paris to become the painter of subjects that were bound to offend his family.

The world of the popular brothel, risqué cafés and noisy cabarets in Montmartre was one that Lautrec frequented happily. His Impressionistic style, criticised as being 'like chopped vegetables' allowed for rapid workmanship in crowded places and was often done on pieces of usefully portable cardboard. He was an early designer of bright, arresting posters and his influence in this field reached well into the twentieth century. Yet his several portraits of his mother show a sensitivity towards his sitter and a quietness in her presence that he sought away from the heady delights of the city.

In nearly every representation he made of her, Countess Adèle is shown with heavy eyelids, looking down. This was sometimes due to her having to keep still while reading. But the expression remains even when there is no book and contributes to an understanding of her subdued nature. In 1883 she bought another château at Malromé near Bordeaux where she occupied herself in managing the vineyards. Here Lautrec often visited her and may have painted her famous portrait with the teacup. It was to Malromé that he finally came to be with her when he died.

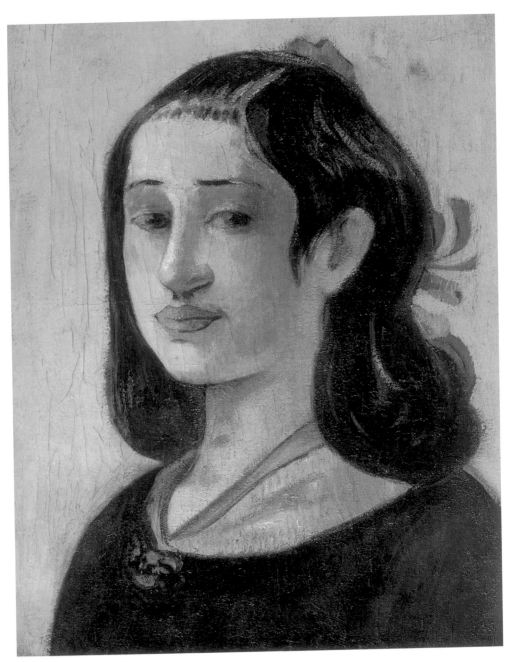

The Artist's Mother 1888
Oil on canvas, 410 x 330 mm
Stuttgart, Staatsgalerie

PAUL GAUGUIN (1848–1903)

Aline-Marie Gauguin (née Chazal)

Aline Gauguin was the daughter of Flora Tristan, a celebrated feminist writer and friend of George Sand. She was descended from a noble Spanish family who had lived in Peru for generations. During her traumatic early life in Paris, Aline was at one time abducted by her father but later struggled to survive as a seamstress before marrying a political journalist. Facing her husband's arrest, she set off with her small family to seek the help of her relations in Peru. Gauguin was an infant when they sailed the Atlantic and on the journey his father died. Determined to survive, Aline stayed six years in Lima within the affluent Spanish-Peruvian society that surrounded her welcoming uncle.

In his early adult years Gauguin became a sailor and again crossed the Atlantic and was away when his mother died. In later life he remembered her with tenderness, especially when recalling the time they had spent in Lima. Among the possessions he carried with him always was a photograph of her taken when she was young and from this he created his portrait.

The painting is very different from the photo and was probably done when he briefly lived in Arles with Van Gogh who also painted his mother from a photograph. Gauguin gave Aline an appealing boldness in her direct, yet smiling expression. He made her mouth thicker and her nose wider to emphasise her Spanish – or Peruvian – ancestry. He simplified the design of the painting, framing her face with thick, straight hair and turning her dress, collar and ribbons to flat and shapely areas of colour set against bright yellow, the colour Van Gogh preferred. This simplification of style was an interest shared with other Post-Impressionists.

Early travels could account for Gauguin's life-long taste for the exotic. He was eager to understand the nature of different people whether from Brittany or Tahiti. Because of his ancestry, Gauguin insisted that his blood was that of a savage. Yet George Sand had once written of his mother, 'This child has the air of an angel.'

Photo of Aline Gauguin c.1840
Private collection

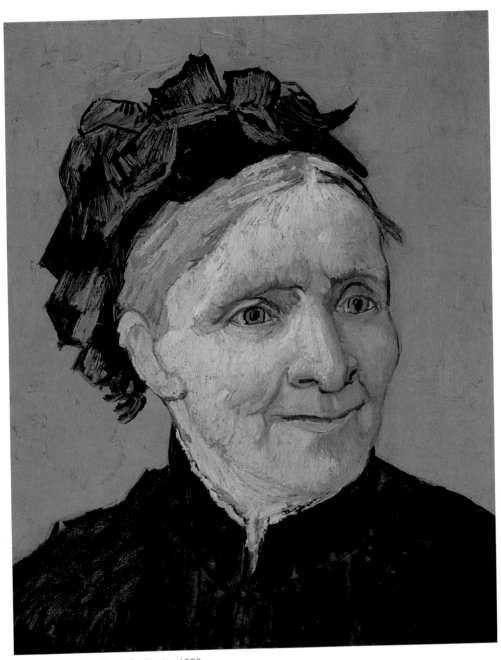

Anna Cornelia Van Gogh-Carbentus 1888
Oil on canvas, 405 x 325 mm
Pasadena, The Norton Simon Museum

VINCENT VAN GOGH (1853–89)

Anna Cornelia Van Gogh-Carbentus

Van Gogh was very close to his younger brother, Theo, who, throughout their adulthood, supported him in his painting career. Letter writing was a popular family activity and it is through reading the words sent between brothers, sisters and parents that we know so many details about their lives. When Vincent's sister Anna moved away after living with him in London, their mother wrote to Theo concerned he'd have no more bacon cooked for breakfast.

Van Gogh hoped to establish a colony of artists in the south of France, in Arles, but only Gauguin joined him. For three months they lived together and worked in close proximity. When Van Gogh received a photograph of his mother in the post he realised that despite the many portraits he had painted, he had never included his parents as sitters.

Whether painting landscape, still life or portraits, Van Gogh wanted his subjects in front of him, explaining 'I am too afraid of departing from the possible and true' to paint otherwise. Yet the photograph was too monochrome for his taste and he decided to depict his mother 'as I see her in my memory.' With his typical thick brush strokes he used a harmony of greens contrasted with dark brown. Having completed the portrait, he was prompted to paint one of his father and asked for his photo to be sent.

Gauguin believed an artist should 'dream before nature' using the imagination as an artistic tool that could transform reality into more symbolic work. The following month Van Gogh painted *A Memory of the Garden* where his mother is less recognisable and his sister Wil resembles the Arlésienne woman who ran his local café. The dotted technique, Pointillism, contributes to the painting's vibrancy. Van Gogh explained, 'I know this is hardly what one might call a likeness, but for me it renders the poetic character and the style of the garden as I feel them ... the deliberate choice of colour, the sombre violet violently stained by the citron yellow of the dahlias suggests mother's personality to me.'

A Memory of the Garden (Etten and Nuenen) 1888
Oil on canvas, 735 x 925 mm
St Petersburg, State Hermitage Museum

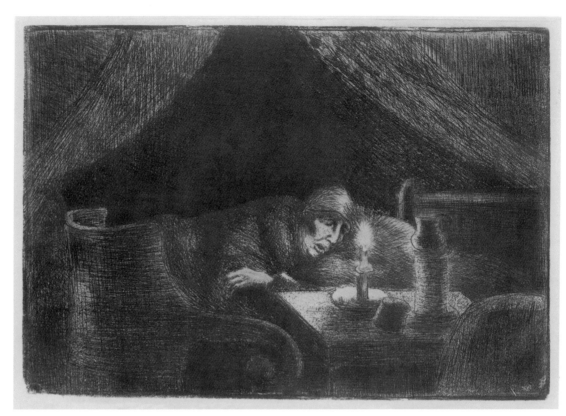

Grandmother, Light Effect 1889
Etching and aquatint, 201 x 311 mm
Boston, Museum of Fine Arts

CAMILLE PISSARRO (1830–1903)

Rachel Petit Pissarro (née Manzana Pomié)

Pissarro was the only Impressionist painter to exhibit in all of their eight exhibitions and is regarded as the group's father figure. He was also a prolific and original print-maker, establishing his own press later in his career. The medium allowed him to experiment with singular effects of light as an alternative to the painted work he and his contemporaries were achieving.

Cézanne once said, 'Pissarro had the good fortune to be born in the Antilles. There he learned to draw without masters.' His Jewish parents ran a small store in St Thomas in the Virgin Islands before coming to Europe with their family and four children from Rachel's previous marriage. She was a strong-willed, deeply emotional woman, not easily pleased and always fearful if her children were ill. Even when Pissarro, aged forty, wanted to enlist to fight in the Franco-Russian War, she wrote, 'I beg of you, don't go and fight. If a misfortune should strike you, what could I do?' Another ploy was to insist 'You are not French, so don't go exposing yourself needlessly.'

Living in the country, Pissarro frequently stayed at his mother's Parisian apartment when visiting the city. Here he struggled to gain recognition (and at times felt his critics were anti-Semitic) and appreciated the support she gave him. He brought his own children to visit her. When she was ill, at the end of her life, he made several drawings of her. Her grandson Lucien wrote that she 'is always very fussy; I believe the poor old lady doesn't have a long time.'

Pissarro portrayed her fast asleep, her characterful face and thin hand lit by the bright candle flame. Pissarro's great predecessor in print-making, Rembrandt, also explored the dramatic possibilties of lighting effects. The picture is carefully composed with the room's furniture – a shapely chair, the bed head, the table – surrounding the sleeping figure beneath dark, falling drapes. She appears peaceful, ready to leave what she had described as 'this world where there are very few pleasures for very many sorrows.' Pissarro also drew her when she lay dead in her coffin.

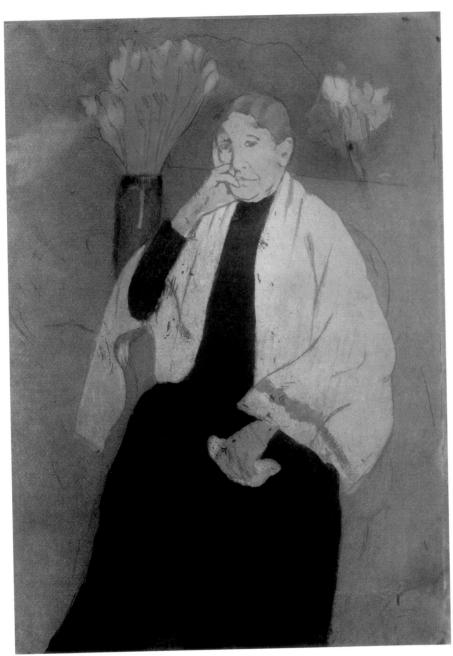

Portrait of the Artist's Mother 1889–90
Soft ground etching and aquatint, 250 x 179 mm
Washington DC, National Gallery of Art

MARY CASSATT (1844–1926)

Katherine Keloo Johnston Cassatt

Mary Cassatt found her art training at the Pennsylvania Academy of Fine Arts limited and felt compelled to go elsewhere. Her mother, of Scots-French descent, had been educated by a French woman. In 1866 she accompanied her daughter to Paris and eventually the whole family moved permanently to the capital where Mary's career flourished. Life here was not unlike the comfortable social scene they had known in Philadelphia and in their Parisian home Mary set up a studio.

As the painter of mothers with children Mary Cassatt excelled in a direct, unsentimental approach. Her work was not restricted to painting and her mother described the progress of her career in letters home that remain a fascinating source of information about Paris and the circle in which Mary pushed herself to succeed: 'Degas, who is the leader, undertook to get up a journal of etchings and got them all to work for it so that Mary had no time for paintings and as usual with Degas, when the time arrived to appear he wasn't ready Degas never is ready for anything.'

The portrait etching of her mother shows Mary's thorough knowledge and understanding of Japanese prints. When trade with Japan had re-opened, these prints flooded the Parisian market, taking the art world by surprise. Conventional ways of showing distance and volume, through light and shade, that the West had learned since the Renaissance were absent. Flat areas of single colour lent a simple decorativeness to designs. Mary Cassatt, like her friend Degas, adopted Japonisme wholeheartedly. The etching has all the striking potential that Japanese art brought to poster design at the time.

Mary nursed her invalid mother until she died. When her own eyesight failed she was forced to give up the work she had so energetically pursued. As her mother once wrote, she had been 'immensely interested in her painting. After all, a woman who is not married is lucky if she has a decided love of work of any kind and the more absorbing it is, the better.'

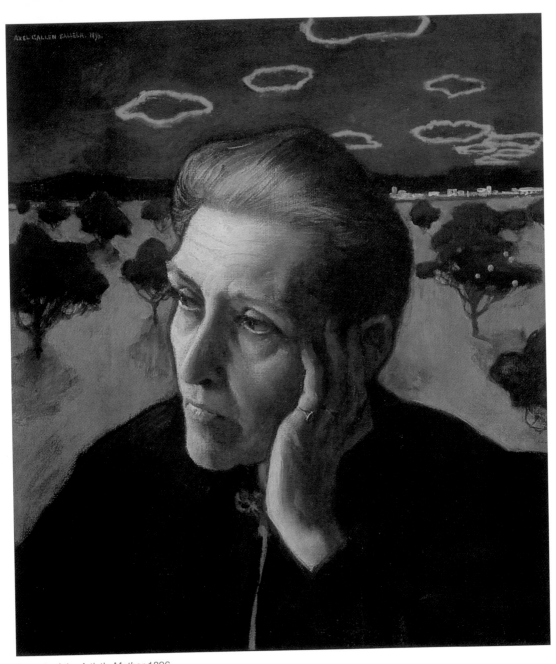

Portrait of the Artist's Mother 1896
Tempera, 330 x 290 mm
Stockholm, National Museum

AXEL GALLEN-KALLELA (1865–1931)

Anna Mathilda Gallén (née Wahlroos)

The folk tales of Finland take place in a land of forest and lake, mountain and sea. Heroes and heroines of the *Kalevala* populate this wild country where events in their adventurous lives demand feats of extraordinary physical and mental strength. The stories were painted by Axel Gallén-Kallela not only on canvas but as commissions for the large walls of public monuments. His life-long dream was to paint a further series illustrating all fifty cantos of the entire myth.

Gallén adopted the name Kallela in a gesture of romantic attachment to the place where he periodically lived and worked in a wooden house at the eastern edge of Finland. The name also hinted at a nobility that did not match his parentage. His father had died when he was fourteen from which time he grew much closer to his mother. To him she was 'fiery and lively by nature … very much herself and quite independent.' She not only painted, taking time to teach her son, but had a keen interest in art and literature. She was also fascinated by

contemporary interest in the mystical and spiritual aspects of life.

Gallén went to Paris and rejected the limitations of Impressionism, so concerned with physical appearances, but responded to the later Symbolist movement. In his portrait of her, Mathilda Gallén occupies a strange and mysterious landscape. Her face is in daring close-up yet she looks away, deep in thought, to an unknown source of light. The stylised red clouds, the bright, distant town and the stark black trees casting red shadows though unrealistic, all contribute to an image of her reflective nature.

In one of his *Kalevala* scenes he again used the powerful contrasts of red, black and white. He chose his mother to represent the grieving mother of Lemminkäinen. Her mournful prayers invoke the gods to pity her and revive her son. Gallén draped his studio with black cloth and insisted on talking about gloomy, upsetting topics – until she wept. Her co-operation with his ploy enabled him to achieve exactly the story's tragic mood.

Lemminkäinen's Mother 1897
Tempera, 850 x 1180 mm
Helsinki, Ateneum

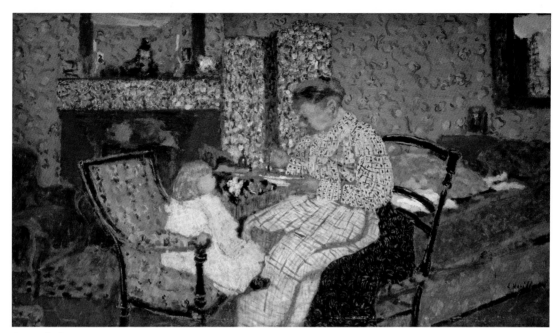

Annette's Soup 1900
Oil on canvas, 352 x 618 mm
Saint Tropez, Musée de l'Annonciade

EDOUARD VUILLARD (1868–1940)

Marie Vuillard
(née Michaud)

Vuillard's mother appears frequently in his scenes of interiors, not as a close-up portrait, but as a permanent presence, sometimes shadowy, almost part of the furnishings.

She was a Parisienne, daughter of a textile manufacturer, and it was back to the capital that she came with her family of three children from the Jura when her husband retired in 1877. She later moved to the busy, commercial area between Opéra and Boulevard des Capucines, centre of the clothing industry, where she joined a firm of corset-makers, gradually taking over the business when she became a widow. Moving the work into their homes, the rooms of their various apartments became true seamstress' workshops. Mme Vuillard was helped in her work by her only daughter Marie.

In this atmosphere Vuillard grew up to become a painter, always interested in design. His maternal grandfather had a showroom of patterned fabrics in the Rue Montmartre. His uncle Sorel designed cashmere shawls. As a child he had collected small pictures and coloured boxes. With all the paraphernalia of haberdashery about him, he was familiar with and fascinated by this busy, colourful world.

Vuillard is known as an Intimist, relating to his illustration of private, domestic scenes that were also chosen by Bonnard, his friend and contemporary. In the charming painting of his neice Annette's supper, he shows his mother feeding her grandchild, although she becomes almost indiscernible in the multiplicity of two dimensional pattern shapes that make up the interior scene.

Living with her until she died, Vuillard was devoted to his mother as she was to him, always supportive of his career. He never married. A friend described her as 'a figure of extraordinary purity and nobility. Marvellous was her tenderness … . She believed in his mission and consecrated herself to it with a conscientiousness and self-denial almost without precedent. It was thanks to her that Edouard Vuillard became the perfect artist whom we know and the man of loyal intelligence, the frank and simple character who has won our sympathies. To her this powerful artist owes the inviolable modesty which he evinced even in the face of unhoped-for triumphs.'

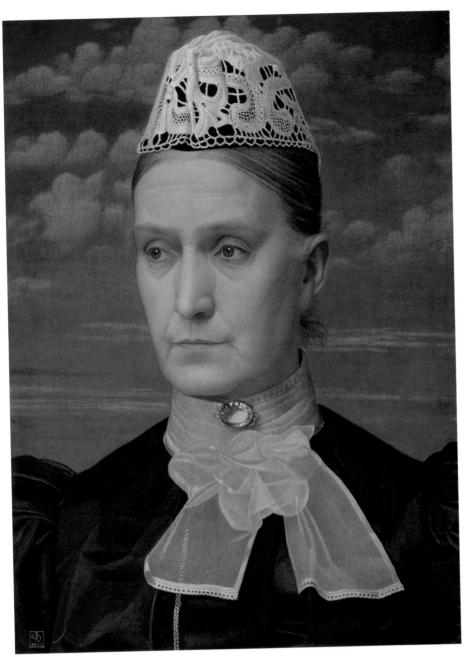

The Artist's Mother 1902
Tempera on mahogany panel, 485 x 355 mm
Birmingham Museums and Art Gallery

JOSEPH SOUTHALL (1861–1944)

Anna Elizabeth Southall
(née Baker)

Southall's parents were both Quakers. His mother, widowed when he was one, went to live with his grandmother in Edgbaston. As a child he was taken by his mother to see York Minster where he was struck by the beauty of its architecture. This early outing prefigured further journeys together abroad. The two travelled to northern France and later, aware of Ruskin's praise of Venice, they visited Pisa, Florence, Siena, Orvieto, Rome, Bologna, Padua, Venice and Milan, returning through Switzerland. Though he had been apprenticed as an architect in Birmingham, he now knew that painting was to be his career. 'I found myself at twenty-one years of age face to face with a vast series of frescoes, so quiet and yet so gay, so reticent and so lively in essence that words must ever fail to convey even the faintest expression of what I felt.' His visit to Italy heralded experiments in tempera painting using the yolk of an egg as the binder for pigments, rather than oil. Fresco painting, being made of fresh, damp plaster, dries to become matt.

Tempera also creates not a surface shine, but an opaque glow. The portrait of his mother, so successful in this non-shiny, almost dulled medium, was painted not long after he had co-founded the Society of Painters in Tempera.

The details of the panel's preparation were recorded by his cousin on his mother's side, Anna Elizabeth. As Southall's technical assistant, she applied layer upon layer of gesso in accordance with earlier Italian methods. Southall waited to marry Anna Elizabeth until they were in their forties, deliberately avoiding having children since they were so closely related.

Southall shows his mother with hair scraped away from her unsmiling face that is framed by the simple Greek lace cap, symbol of widowhood, that he himself designed. The yellowy citrine brooch clasps her neck-lace tight around her chin. Southall considered the portrait one of his best works and offered it to the nation. It was subsequently bought to hang in Birmingham, where it is now and where he had always lived.

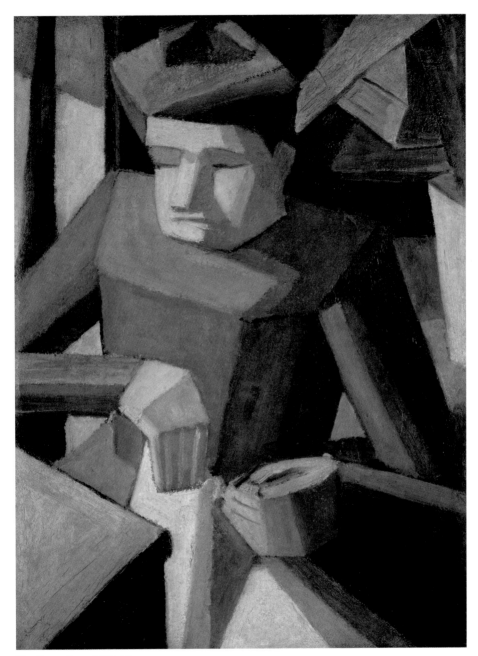

The Seamstress 1909–10
Oil on canvas, 720 x 540 mm
Paris, Musée Nationale d'Art Moderne,
Centre Georges Pompidou

FERNAND LEGER (1881–1955)

Marie Adèle Léger (née Daunou)

Léger's father, a livestock breeder, died when Léger was only three. 'My mother was a saintly woman,' he remembered. 'After she became a widow all the family possessions gradually melted away and she was very worried when she saw me getting an interest in painting.'

An early work of his mother's garden shows an understanding of Impressionism, which he discovered on first coming to Paris from the country in 1900. Six years later a large retrospective exhibition of the works of Cézanne was held there and many artists (such as the young Picasso) were encouraged to look at nature in the way Cézanne had advised, by seeing it in terms of 'the cylinder, the sphere, the cone'. This emphasis on volume rather than colour was one aspect of Cubism.

Léger's painting of his mother shows how he willingly embarked upon the Cubist style. She appears doll-like and mechanical, as if her flesh and surroundings have all been turned into hardened materials. Little of her 'saintly' character is seen. Léger used none of the bright colours being used by Matisse and the Fauves at the same time, but more sombre tones of brown and grey. The figure is lit by a light source on the left and all the shadows are arranged in bold strips that contribute to the angularity of the forms.

In 1911 the writer Apollinaire described Léger's art as 'difficult. He creates, if one dares say it, symmetrical painting and he does not avoid giving his composition a wild appearance – like a heap of inflatable tyres.'

Léger's attraction towards Cubism was a starting point for his later unusual style. After the First World War, when he had served in the trenches, he became fascinated by machines – their power, their particular kind of static beauty and their significance as images of the modern world.

When his mother died in 1922 Léger inherited the family farm. Though he continued to work in Parisian studios, it was in the country where he had grown up that he was able to indulge his love of nature. He worked on the farm until his own death.

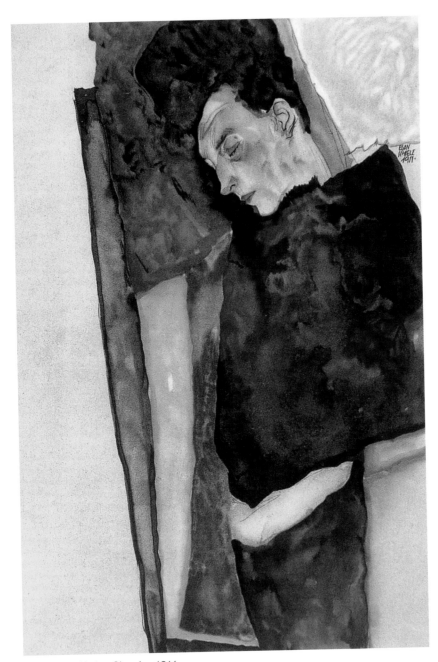

The Artist's Mother Sleeping 1911
Pencil, watercolour and white body colour on paper,
450 x 316 mm
Vienna, Graphische Sammlung Albertina

EGON SCHIELE (1890–1918)

Marie Schiele
(née Soukup)

Family legend accounts for the story that Schiele's father, aged twenty-four, met his mother when she was twelve and vowed to marry her. She was convent educated and still playing with dolls when, five years later, she became his wife and fled the room in horror on her wedding night. At the same time her husband contracted syphilis which he refused to have treated. Several of their children died but when their only son, the artist, was born, Marie wrote in her diary that he was a 'dear, strong child … God preserve him for us. May he grow and flourish!'

Schiele's father encouraged a love of the countryside in his son and himself was a keen draughtsman though Egon drew obsessively (from the age of eighteen months, his mother later claimed). He annoyed his school teachers by continuing his drawings throughout lessons. At sixteen he became an art student and soon sought out his idol, Gustav Klimt, who was to remain an influence in his early work. Schiele's short career saw him develop as one of the major figures of Austrian Expressionism.

In the sleeping portrait of his mother, the flesh tones of her face and hands are surrounded by bands of worked-up colour, like a montage, that emphasise her stillness. The image is often placed vertically, denying the horizontality of sleeping, but, together with the patterning, lending the figure a purely decorative aspect.

He produced countless drawings of naked models emphasising their sexual nature in contorted poses made of stark, angular outline. The psychological aspects of desire fascinated him and his fearless depiction of the animality of the human body invited contemporary criticism, as did his personal behaviour. He was sent to prison under suspicion of seducing an under-age girl but the experience encouraged his determination to express himself through his art. 'All beautiful and noble qualities have been united in me,' he wrote to his mother, 'I shall be the fruit which will leave eternal vitality behind even after its decay. How great must be your joy, therefore, to have given birth to me.'

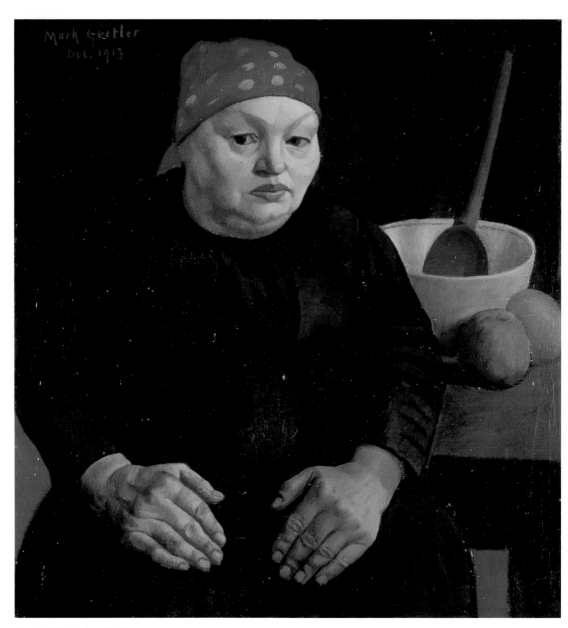

The Artist's Mother 1913
Oil on canvas, 444 x 419 mm
Swansea, Glynn Vivian Art Gallery

MARK GERTLER (1891–1939)

Golda Gertler (née Berenbaum)

Gertler was born in a slum in London's East End in the Jewish community to which his family had come from Galicia in Austria in 1866. His father made no success in the furrier's trade, so they returned home to run an inn. Here the charming infant Gertler was sometimes taken from his cradle by his mother, Golda, to be shown off to demanding drunken soldiers. She was forced to look after her five children alone when her husband fled to seek a better life for them all in America. They sailed back to England. Though she spoke fluent German, Polish and Yiddish she knew little English as they started a new life, yet again. On the boat journey the five year old Gertler once more entertained an audience. Had it not been for him, Golda recalled, and the scraps of food they were given, they might never have survived. Such were the conditions under which Gertler developed his deep fondness for his mother.

When he was seventeen he was sent to the Slade School of Art by the Jewish Educational Aid Society in recognition of his work. An early portrait of his mother shows her sitting, hands clasped, her bulky frame clothed in simple finery. In this later work he portrays her in the domestic situation he knew so well – in the kitchen, preparing a meal. The painting shows his knowledge of Post-Impressionism with its simplification of forms and preference for flat areas of colour. 'She sits bent on a chair, deep in thought,' said Gertler. 'Her large hands are lying heavily and wearily in her lap. The whole suggests suffering and a life that has known hardship. It is barbaric and symbolic. Where is the prettiness!'

In 1932 Golda died having greatly suffered from the pain caused by an earlier hip injury. Though he had married, Gertler felt her absence keenly. His wife claimed the trouble he'd known trying to find the right woman was because of his attachment to his mother. Gertler committed suicide in 1939 after years of mounting depression.

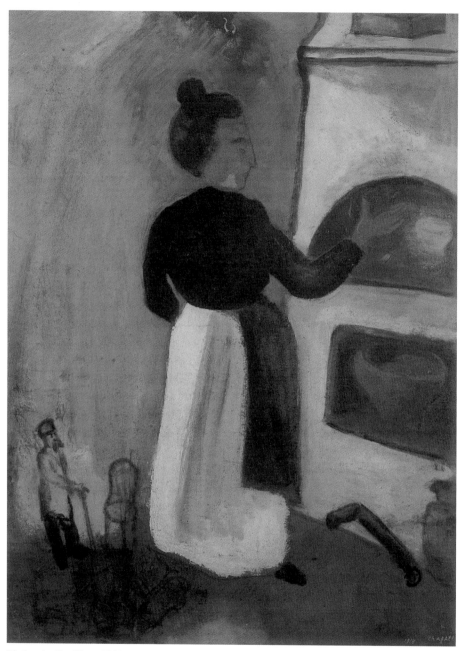

Mother by the Stove 1914
Oil on canvas, 630 x 470 mm
Private collection

MARC CHAGALL (1887–1985)

Feiga-Ita Segal

Fantasy, humour, love and poetry – all can be found in Chagall's lively and colourful paintings. Throughout his career he produced bright, dream-like images that often illustrated moments in his life. 'If I have made pictures,' he wrote, 'it is because I remember my mother, her breasts which have warmly nourished and exalted me and I am ready to hang on the moon.'

His autobiography is a sweep of recollections which begin with his birth. Here, as in his painting, his descriptions owe more to his imagination than reality. A fire broke out in Vitebsk, the small Russian town near the Lithuanian border where his family lived. Chagall gives the date and time of his birth as coinciding with the fire, though it is recorded as happening the day before. 'They carried the bed and mattress, the mother and the baby at her feet, to a safe place at the other end of the town'

Chagall emphasised, with affection, life in the Judeo-Christian community where his mother's efforts saved them from poverty. 'I can see her ruling the whole house, directing my father, endlessly building little houses, starting a grocer's shop, bringing in cartloads of goods bought on credit. What words, what means can I use to portray her smiling at the doorway, or seated for hours at the table, ever waiting for some neighbour to whom she might unburden her soul?'

In the painting of his mother by the stove he uses uncharacteristic subdued tones that are enhanced by strong light falling on her apron and the stove. He captures her dominance in the domestic sphere by using symbolic proportions, a device known in religious painting and in folk art. She occupies the whole of the central space. Hardly discernible, less vivid even than her cooking utensils, Chagall's father stands by a tiny chair, his stick in hand, looking up at her.

In his book Chagall included a sketch of himself at his mother's grave. 'Tell me mother: from the other world, from paradise, from the clouds, from where you are,' he wrote, '... does my love comfort you?'

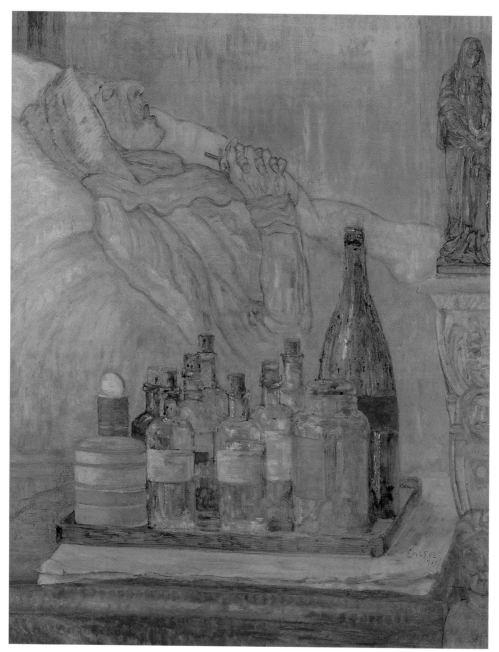

The Artist's Mother in Death 1915
Oil on canvas, 750 x 600 mm
Ostend, Museum voor Schone Kunsten

JAMES ENSOR (1860–1949)

Maria Catharina Ensor (née Haegheman)

James Ensor's English father spent much time away from his home in Ostend which was above his mother's seaside souvenir shop. As a child he was surrounded by several female members of his family as well as the dazzling paraphernalia of a world filled to bursting with bizarre objects; from Oriental curios to carnaval masks and fancy dress. As he explained, they lived 'in the midst of gleaming, mother-of-pearl-coloured shells with dancing, shimmering reflections and the bizarre skeletons of sea monsters and plants. This marvellous world full of colours, this superabundance of reflections and refractions made me into a painter.'

The women were industrious if eccentric. Aunt Mimi walked about with a pet canary in a cage. Ensor's sister married a Chinese dealer of masks and exotic furnishings (who vanished from the family a year later). When his father died, Ensor remained dependant on his mother's financial support.

Much of his extraordinary vision of the world stems from this home environment. At seventeen he began studying art in Brussels but continued his career from a studio in the attic. Early paintings include dark interiors, portraits, sea and landscapes. By the late 1880s fantastic elements and Biblical themes had entered his work. One huge canvas shows Christ entering Brussels surrounded by swarms of grotesque carnaval characters.

Death and its associations fascinated Ensor. Skulls, skeletons and staring masks inhabit his unreal and uneasy world. When his aged mother became ill, he cared for her over a long period. As she was dying he made at least four different likenesses of her. Here she appears like a distant spectral outline, her face sharply in profile. The more immediately arresting and vivid foreground contains her bright medicine bottles all displayed on a tray. They take the form of a still life with light flickering across their glass surfaces. Each bottle is set upright and fully corked, as if their contents are no longer required by the motionless patient lying behind them who clutches a crucifix with her bony hands. The small religious statuette to the right suggests Ensor's mother has already left their dazzling, colourful world.

Portrait of the Artist's Mother 1917
Lithograph, 278 x 200 mm (image), 580 x 388 mm (sheet)
San Francisco, Fine Arts Museums of San Francisco

OSKAR KOKOSCHKA (1886–1980)

Romana Kokoschka
(née Loldl)

Kokoschka's mother came from the mountainous area of Styria in south eastern Austria. She grew up with many brothers and sisters in this densely wooded region removed from civilisation where few roads passed. Despite the isolation, her inquisitive nature led her to seek greater knowledge further afield. She was said to have a gift for second sight and was an impressive storyteller. She inspired in the artist a profound love of nature that can be seen in his choice of landscape painting as a subject throughout his career.

As a portrait painter Kokoschka wanted to reach beyond the physical appearance of the sitter which he considered to be only a facade. His looming, staring and often distorted faces suggest not so much the nature of these people but more about his own restless and energetic creativity. The portraits are often vitalised by quivering, wiry lines suggesting arrested movement. This liveliness is present in the lithograph drawing of his mother with her piercing eyes and characterful mouth and chin. His technique helped to reveal her spirited and alert mind.

Kokoschka's colourful, dynamic and daring style – in painting and in his literary work – led him to be called 'the wildest beast of all' on the Viennese art scene of the early 1900s. At the time when Sigmund Freud's recent work on the unconscious was well known, his plays covered themes of sex, violence and conflict between men and women. He fell in love with the composer Mahler's widow but after some years the relationship became tortured, provoking Kokoschka's mother to write to his lover saying, 'If you see Oskar again, I'll shoot you dead.' Joining the cavalry in the First World War was a way for him to recover from the affair.

Despite being seriously wounded during the war, he survived to dispel his early reputation of 'mad Kokoschka' and became deeply committed to expressing his political and humanist ideas. He believed in education and the power of example and felt that the full experience of his own life was a means of teaching and helping others.

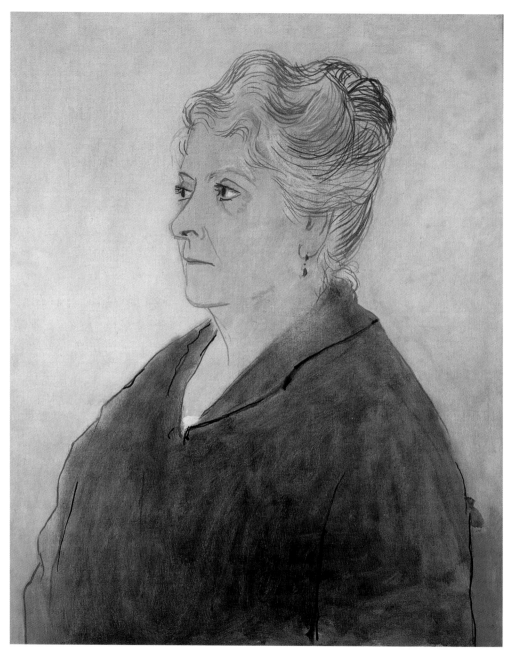

Portrait of Maria Picasso López 1923
Oil on canvas, 730 x 600 mm
Arles, Musée Réattu

PABLO PICASSO (1881–1973)

María Picasso López

Picasso once commented that all the men in his work were in some way representations of his father. The same idea could not be applied to his mother. She is the first of many individual women who figured in Picasso's life and in his art. In paintings, sketches, drawings, sculptures, ceramics and engravings he explored the different types of media to express his own nature. How he portrayed these women reveals much about Picasso's personal relationships with them.

María Picasso López (from whom he took his name) was energetic, enterprising and wisely industrious in times of need. Her family's vineyards had failed and when she married she brought to her marital home few material resources, but later two of her sisters. Picasso received doting female attention as a child which probably contributed to his alarming self-confidence. His mother claimed his first word was 'piz' for *lápiz* (pencil). His father, a teacher of drawing, like her did not discourage Picasso from becoming an artist.

Picasso did several portraits of his mother and the latest of these was done in Cap d'Antibes where she joined him for a holiday. She is shown in a simple and striking pose, her facial features, including the gaze of her keen, dark eyes, achieved through a few lines. The paint, used more like watercolour than oil, is loosely applied within these firm lines. In an earlier portrait, painted when Picasso was only fifteen, the paper surface is divided into specific areas with her thick, dark hair and firm profile occupying the upper part while a fluffy, pale fabric covering her ample chest takes up the lower part. The light handling of this mass is due to the nature of pastel as a medium and, together with the tiny detail of her earring, enhances a sense of her femininity.

Dona Maria was very short (Picasso is said to have been embarassed that when sitting on a chair her feet did not reach the floor). However, Picasso's widow, Jacqueline, said that though he was uneasy about his mother's homely appearance they had a 'surprisingly uncomplicated relationship'.

*Maria Picasso López,
the Artist's Mother* 1896
Pastel on paper, 498 x 390 mm
Barcelona, Museu Picasso

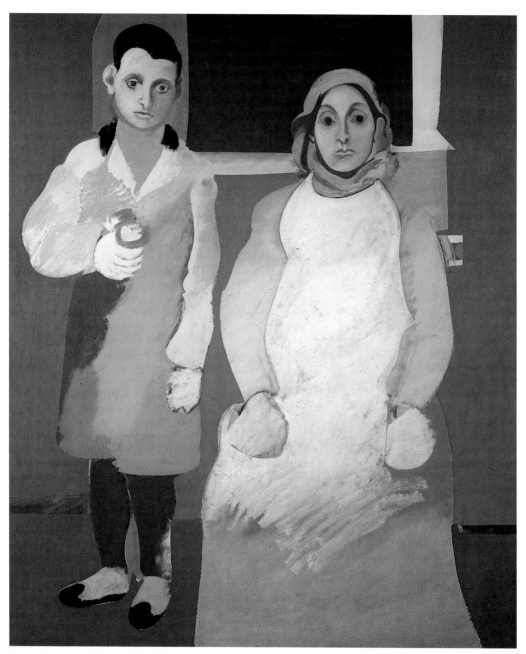

The Artist and his Mother 1926–36
Oil on canvas, 1524 x 1270 mm
New York, Whitney Museum of American Art

ARSHILE GORKY (1904–48)

Shushan Adoian
(née Marderosian)

Shushan der Marderosian was sixteen, a widow with two daughters, when she married Sedrak Adoain, a peasant farmer and widower, with one boy. Gorky's Armenian parents had both been married to spouses who were massacred during Turkish persecution. At the time of her second marriage, Shushan was required to send her older daughter to an orphanage where the child died. In her new marital home, as the youngest woman, her role was subordinate and physically arduous. There was little affection between her and her husband. Relief from the demands of her domestic sphere came when she walked to the lakeside church of her own family home. Shushan remembered her past with nostalgia. As a child Gorky buried his head inside her apron and listened to the lovely tales she told of the mountainous countryside where people always sang and danced. Gorky himself worked as a shepherd boy there.

When he was still a child, Gorky's father left for America, escaping conscription into the Turkish army. He and his mother posed for a photograph to send him as a souvenir and this became the source for his portrait painted many years later. Sketches and a carefully composed grid-drawing were preparatory work towards an almost confrontational image. From the tame, posed studio photo, Gorky transformed mother and son into an unforgettable portrait of two figures whose individual expressions demand attention. She sits defiantly, hands on her lap, her dark eyes and rigid mouth challenging anyone who addresses her. He stands near, pensive and wistful.

Gorky applied single layers of paint that, when dry, he scraped and flattened before adding the next layer, creating a thick surface where little modelling was included. He chose cool, contrasting colours and bound them strictly within sharp outlines. This bold method greatly contributed towards the painting's haunting power.

Gorky's mother died in his arms after a 120-mile march. He and his sister made their way to the coast and by ship to freedom in America. From then he began his career as an artist, starting with the documentation of his family.

Photograph of Gorky and his
mother, Armenia 1912
Private collection

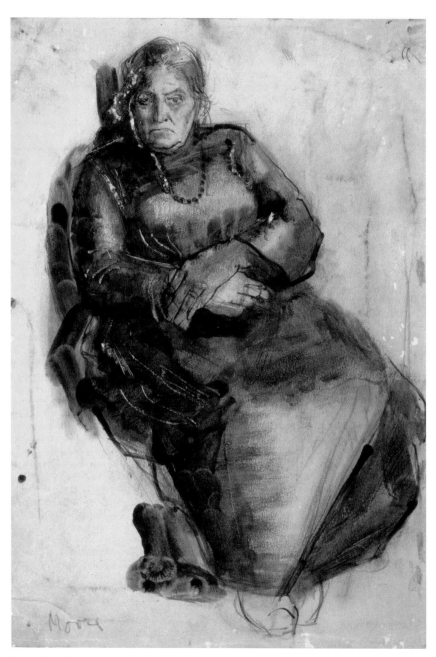

The Artist's Mother 1927
Pencil (rubbed), pen and ink on cream wove, 277 x 191 mm
Much Hadham, The Henry Moore Foundation

HENRY MOORE (1898–1986)

Mary Moore (née Baker)

Drawing formed a major part of Moore's training at the Royal College of Art where he gained a scholarship to study sculpture. His studies, however, were not as fulfilling as the time he enjoyed alone in the British Museum. Here he experienced carvings of other cultures and learned much from African, Oceanic and above all, Pre-Columbian art. Throughout his career the female figure, in particular, engaged his imagination and appeared not only in his Mother and Child groups but also where his sculptures took on the the forms of mountain and valley, cliff and cave suggesting the British landscape.

Moore described his mother as 'absolutely feminine, womanly, motherly'. He was the seventh of eight children, the last of whom died. Their father was a coal-miner and their mother's domestic work was physically arduous. Suffering from arthritis and its accompanying sciatica, Mrs Moore asked Henry as a child to rub her painful hip. Later he acknowledged that this experience, when he felt the natural softness of her flesh over the firmer structure of her bones, had encouraged his desire to sculpt.

The striking sketch of his mother was done at a time when almost all his sculptures were of wood or stone and worked out in preparatory drawings. Here, as if she too might be the subject of a sculpture, he reveals the broad vision with which he addressed her large shape. The brisk, rubbed touch of the outline contains sweeping, fluid, darker strokes. Light falls below her knees in a triangular shape like a single plane. Light covers half her face, and falls on her breasts, hands and arms to emphasise their volume. She appears monumental – a bold, impressive and memorable image.

'She was to me the absolute stability, the whole thing in life that one knew was there for one's protection,' said Moore about his mother. 'If she went out, I'd be terrified she wouldn't return. So it's not surprising that the kind of women I've done in sculpture are mature women rather than young.'

Henry Moore's mother Mary c.1908
The Henry Moore Foundation
archive

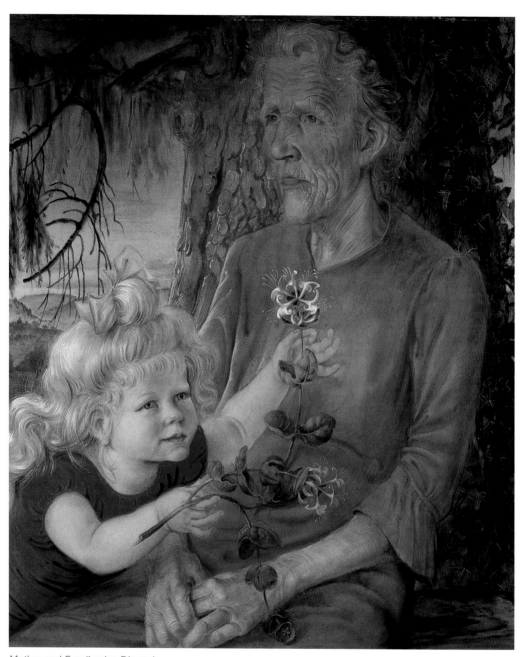

*Mother and Eva (Louise Dix and
Granddaughter Eva Kolberg)* 1935
Mixed media on plywood, 804 x 700 mm
Essen, Museum Folkwang

OTTO DIX (1891–1969)

Pauline Louise Dix (née Amann)

Dix's parents were working class, his father an iron foundry worker and his mother a seamstress, also employed in a porcelain factory. Dix painted two similar portraits of them, three years apart, showing them wearing their (same) sturdy, everyday clothes, resembling striped uniforms. In the first they are slightly bent, unsmiling, the details of their very large hands given the same emphasis as their lined faces. Included in the later work, above their characterful sofa, is a paper pinned to the wall identifying them: 'My father 62, my mother 61 years old,' although they appear much older.

Dix's mother came from south-west Germany. As a young woman she had been able to explore her own creativity by writing poetry. She was able to pass on her love of music to Otto and it was in the studio of her nephew, a painter, that he formed his own desire to become an artist.

Both world wars profoundly affected Dix and his work. In the First World War he fought in the Battle of the Somme. He painted such scenes as *The Trench* and *War Cripples*. The Nazis, accusing him of degeneracy, fired him from his art teaching post and forced him to join the Reich Chamber of Fine Arts, painting only landscapes. In 1939 he was accused of being involved in a plot against Hitler. Though much of his work, which included depictions of Weimar society, appears grotesque, exaggerated and offensively realistic, he claimed he found ugliness beautiful.

This painter of ugliness managed to create a striking work in the later portrait of his mother with one of her grandchildren. As the inheritor of northern European artistic tradition, he here lent reality a dignified beauty. The child looks up and smiles whilst playing with strands of honeysuckle. The grandmother is framed by an ancient tree (as gnarled as her own aged face) yet behind her, in the distance, as in the oil paintings of the Renaissance, a landscape is revealed, moving into a hazy, indistinct skyline. She sits still and upright, staring into the distance, undistracted by the child.

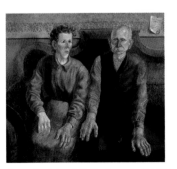

Portrait of the Artist's Parents II 1924
Oil on canvas, 1180 x 1305 mm
Hanover, Niedersachsische
Landesgalerie

My Grandparents, My Parents and I 1936
Oil and tempera on metal, 307 x 345 mm
New York, The Museum of Modern Art

FRIDA KAHLO (1907–54)

Matilde Kahlo (née Calderón)

At the age of eighteen Frida Kahlo suffered a traumatic road accident after which she was frequently hospitalised for treatment. At first she was confined to bed and her mother asked a carpenter to fix up an easel with which she could paint. For the rest of her life she created scenes that portray her fascinating autobiography. 'I paint myself because I am so often alone and because I am the subject I know best.'

She appears in the painting of an unusual, yet informative, family tree. Frida, the child, stands in the house in Coyoacàn, Mexico City, where she was born, where she died and which has become a museum containing her work. The image of her parents comes from their official wedding photograph. Frida holds a double ribbon which reaches round her father to his own parents who were German and are seen hovering above the sea. The ribbon leads also to her maternal grandparents who float above the arid mountains and cacti of their native Mexican landscape. Frida also shows herself as a foetus, attached to her mother

and below this, the very moment of her conception, not far from a pollenating cactus plant.

Matilde Kahlo, convent-bred and a pious Catholic, was very strict. 'My mother was hysterical about religion … . We had to pray before meals', Frida recalled. She was also unhappy when her daughter married a rich, ugly, non-believer and Communist, the celebrated painter, Diego Rivera.

The photo-based image of her parents recurs in Frida's work where she stresses her descendancy. She was unable to sustain a pregnancy herself and painted brutally stark images of physical suffering. Most startling of all is the painting of her birth, done at the time her mother was dying and showing her as a shrouded corpse. The whole scene, resembling an Aztec sculpture of a goddess giving birth, is dominated by a *mater dolorosa* image of the Virgin as weeping mother.

Frida Kahlo claimed she was born three years later than the real event, giving the date as 1910 – the year of the outbreak of the Mexican Revolution.

My Birth 1932
Oil on metal, 305 x 350 mm
Private collection

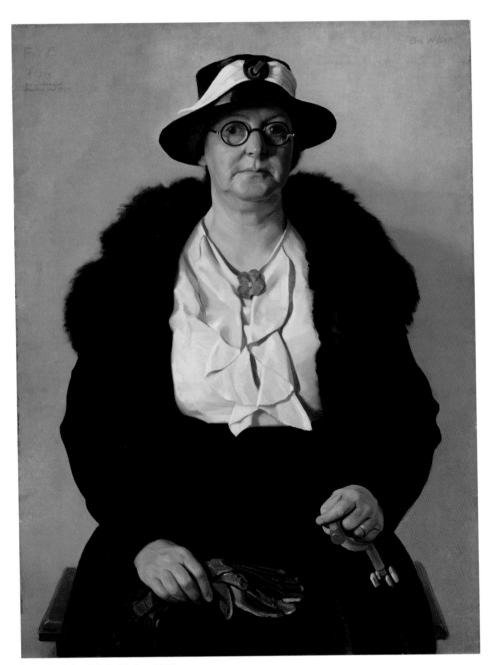

Portrait of the Artist's Mother 1937
Oil on canvas, 950 x 716 mm
Canberra, National Gallery of Australia

ERIC WILSON (1911–46)

Madeline E. Wilson

As a young artist Eric Wilson's work reflected the teaching he had gained from the Sydney Art School. Here students had been encouraged to paint faithfully from nature, with the subject matter before their eyes and an emphasis on sound pictorial structure. He won several signficant prizes as he developed his style but the one he coveted most – The New South Wales Travelling Art Scholarship – eluded him for years. Undaunted, he continued to apply until the several works he submitted in 1937 brought him success. One of these was the portrait of his mother.

If realism was the trademark of his training, it was perfectly achieved in this painting. His mother, sitting emphatically in front of him, is decked up in smart clothes, gloves, umbrella and hat all ready for an outing. Portraiture in the past shows how touches of white can set off a figure placed against darkness. Here, Wilson places the dark tones of her coat and skirt and the shapely hat against a pale background with the creamy blouse taking up the central space. His understanding of colour patterns is also seen in his subtle use of red. Hints are already there in her flesh tones, but the whole figure is further warmed by touches on her umbrella handle, brooch and the clasp across her white hat-band.

The adjudicator for the prize wrote, 'In all Wilson's exhibits it is to be noted that as against his competitors he chooses not the most spectacular subject matter but that kind which would give him the greatest opportunities for research … . His painting of a lady's portrait is the best exhibit, showing clearly the desire to found his work on a rational basis of evaluation.'

The prize allowed Wilson to travel for over a year throughout Europe before the outbreak of war. In Paris and London he discovered very different artistic trends from those he had known in Australia. He later developed themes on abstraction and in particular urban landscapes but he also returned to portraiture, painting his mother again in similarly large, bold, characterful canvasses.

Large Interior: London W9 1973
Oil on canvas, 915 x 915 mm
Chatsworth, The Devonshire Collection

LUCIAN FREUD (born 1922)

Lucie Freud
(née Brasch)

'I paint people,' Freud said, 'not because of what they are like, not exactly in spite of what they are like, but how they happen to be.' Freud's mother figured in his paintings from the early 1970s, after she had become a widow. 'If my father hadn't died I'd never have painted her. I started working from her because she lost interest in me; I couldn't have, if she'd been interested.'

Freud's powerful portraits of the people who featured in his life often show them in particular interior settings. For this painting he brought his mother to sit in the upstairs back room of a terrace house in Maida Vale. Here too was his girlfriend, Jacquetta Eliot, seen lying on the bed behind her. Though both women were closely connected to the artist – his mother was grandmother to the woman's child – they appear absorbed by their own, separate thoughts, bearing little relation to each other, except for their proximity within the room. They never posed like this, at the same time, though it is said that Lucie Freud did hear Jacquetta

smashing things in the next room. Their isolation and separateness is deliberate, bringing them together only physically, not emotionally. Distance, at such close quarters, is uncomfortable.

Although the older, dressed woman is placed in the heart of the picture, the younger, naked one behind her is no less arresting. The room's perspective is distorted with the bed placed horizontally while the armchair sits upon a sloping floor. The pestle and mortar, containing the artist's crushed charcoal to be added to his paint (he wanted his colours to be 'as Londony as possible') is another focal point that seems as incongruous as the uncommunicating figures.

Freud explained the difficulty he had in painting his mother: 'She barely noticed, but I had to overcome a lifetime of avoiding her. From very early on she treated me, in a way, as an only child. I resented her interest; I felt it was threatening.'

'My mother said that my first word was *alleine* which means alone. Leave me alone.'

My Mother, Bolton Abbey, Yorkshire, Nov. 1982 1982
Photographic collage, Edition: 20, 1207 x 696 mm
Collection of the artist

DAVID HOCKNEY (born 1937)

Laura Hockney
(née Thompson)

When he was a student at the Royal College of Art in 1960, Hockney was deeply affected by a major exhibition of Picasso's work. He realised that an artist need not adhere to a particular style of painting, but that all media, all styles, all influences and all choices lay open to him. Early in his career he took up photography, at first using simple Polaroids. A hurried snapshot could become the study for part of a large composition. Throughout the following decades he used more sophisticated cameras. Carefully selected shots of people formed the essential preparation from which he based many portraits. Later he used photocopiers, fax machines, and computer-generated images.

Using many individual photographs of one scene, Hockney was able to explore further what Cézanne had done with his Cubist work – create multiple views that may distort the appearance of the real world but that help explain the way we see it. He photographed his mother alone – yet not quite alone – his own shoes are visible at the bottom of the collage. Unlike the celebrated bright blue of his Californian skies and swimming pools, Hockney's native Yorkshire location is filled with greyness and damp. He shares the scene where she sits upon funereal tombs, musing.

Hockney's mother, who lived to almost a hundred, was one of his favorite models. He made many drawings of her from studied, frontal close-ups to a hurried sketch on the way to her husband's funeral. When both parents were alive he painted them as a couple, twice, continuing his interest in double portraits. In one he wanted to show their 'predicament, their lack of fulfilment, the desperate not-knowing what they could have had out of life.' He also shows himself, in a mirror between them. In the later painting he implies a psychological distance as his mother obediently sits and his restless father reads a book. He took over five dozen preparatory photos for the painting, achieving in it his typical blend of naturalism and clarity.

The Artist's Mother at 18 and 88 1989
Oil on canvas, 711 x 915 mm
Oxford, Ashmolean Museum

TOM PHILLIPS (born 1937)

Margaret Agnes Phillips (née Arnold)

Both Tom Phillips and his mother wrote about their lives – she recalling her past, he amplifying her descriptions. He wrote about the origins of this painting. Unusual as it is, with an image of the younger woman in front of a picture of the older one, it is reminiscent of illustrations of the ages of man – childhood, youth and old age – such as Titian painted. Here, ingeniously portrayed, are two specific ages of a certain person – the artist's mother.

When his father's business speculations failed, his mother, taking charge of the situation, bought a large house in Peckham that she let to many entertaining characters. This later became Tom's own lodgings when he studied at Camberwell School of Art. Eventually he took it over entirely, turning it into his permanent studio and home. The portrait was painted at that same house though 'the studio itself soon disappeared in favour of a fictional wall of memory with a wallpaper based on recollections of the decorative boxes that my mother used for her cosmetics

and that she had kept from before her marriage.'

Phillips explained that his mother came round to the studio on Saturdays for lunch and during the afternoon it became a habit for him to draw or paint her. The foreground image was based on an old, tatty and blurred photograph of his mother that was taken when spending a 'daring weekend' with a boyfriend by the sea in 1919, a memory that made her sigh. The older woman, aged eighty-eight, was painted direct from life.

The impact and strength of the painting lies in the immediacy of this double-take and what it suggests. When we look back over our lives, we see ourselves in our mind's eye. Phillips could have painted the older woman standing in front of the photo-image, implying this backward, possibly nostalgic glance. Instead, he reversed the two figures. 'Old age, after all, no more nor less includes our former selves than youth contains the inevitability of our selves to come,' said Phillips. 'That is why both ends of the time spectrum have their poignancy.'

INDEX

Artists whose mothers appear
in the book are in *italic*

ACKNOWLEDGMENTS

The Publishers would like to thank those listed below for permission to reproduce the artworks on the following pages and for supplying photographs. Every care has been taken to trace copyright holders. Any copyright holders we have been unable to reach are invited to contact the publishers so that a full acknowledgement may be given in subsequent editions.

PAGE 1 Photo: Michel Muller. Reproduced by permission of the Henry Moore Foundation; gift of Mary Moore Danowski 1979 PAGE 11 Courtesy Springville Museum of Art PAGE 13 Photo: akg-images, London PAGE 16 © 2006. Photo Scala, Florence – courtesy of the Ministero Beni e Att. Culturali PAGE 22 © The Bridgeman Art Library/ Peter Willi PAGE 24 Courtesy Colchester and Ipswich Museum Service PAGE 26 © Roumagnac Photographe PAGE 28 © Tate, London 2008 PAGE 30 Courtesy Muzeum Sztuki, Lodz PAGE 36 © The Bridgeman Art Library. Washington DC, National Gallery of Art; Chester Dale Collection PAGE 46 The Metropolitan Museum of Art, Purchase, Joseph Pulitzer Bequest, 1951; acquired from The Museum of Modern Art, Lille P. Bliss Collection (55.21.1) Image © The Metropolitan Museum of Art PAGE 60 The Art Archive/ Musee de l'Annonciade Saint Tropez/ Laurie Platt Winfrey © ADAGP, Paris and DACS, London 2009 PAGE 62 © George Harrison Barrow. Reproduced by permission of the Barrow Family. Courtesy Birmingham Museums and Art Gallery PAGE 64 © ADAGP, Paris and DACS, London 2009. © Photo CNAC/ MNAM, Dist. RMN/ © Jacques Faujour PAGE 68 City & County of Swansea: Glynn Vivian Art Gallery Collection. Reproduced by permission of the Gertler Estate PAGE 70 © ADAGP, Paris and DACS, London 2009 PAGE 72 © SABAM, Brussels and DACS, London 2009 PAGE 74 © Foundation Oskar Kokoschka/ DACS, London 2009. Fine Arts Museums of San Francisco; bequest of Ruth Lilienthal 1975.1.39 PAGE 76 Photograph Musee d'Arles PAGE 76, 77 © Succession Picasso/ DACS, London 2009 PAGE 78 © ADAGP, Paris and DACS, London 2009. Whitney Museum of American Art; Gift of Julien Levy for Maro and Natasha Gorky in memory of their father 50.17 PAGE 80 Photo: Michel Muller. Reproduced by permission of the Henry Moore Foundation; gift of Mary Moore Danowski 1979 PAGE 81 Photo: Henry Moore Foundation archive. Reproduced by permission of the Henry Moore Foundation PAGE 82, 83 © DACS, London 2009 PAGE 84 Museum of Modern Art, New York; Gift of Allan Roos, M.D. and B. Mathieu Roos PAGE 84, 85 © 2009 Banco de Mexico Diego Rivera & Frida Kahlo Museums Trust, Mexico DF./ DACS, London 2009 PAGE 86 Courtesy National Gallery of Australia; Purchased 1975 PAGE 88 © Devonshire Collection, Chatsworth. Reproduced by permission of Chatsworth Settlement Trustees. Photo by John Riddy PAGE 90 © David Hockney PAGE 92 © Tom Phillips. All Rights Reserved, DACS, London 2009. Courtesy Ashmolean Museum

JULIET HESLEWOOD studied History of Art at London University and later gained an MA in English Literature at Toulouse. For over twenty-five years she lived in France where she devised and led study tours on art and architecture as well as continuing her writing career. Her books include *Introducing Picasso* and *The History of Western Painting* for young people which was translated into twelve languages. She also wrote its companion on sculpture and has published collections of world folk-tales. Juliet now lives in Oxfordshire where she continues to write on both art and folklore and is a freelance lecturer in History of Art.

The Author's Mother
My digital camera allowed me to snap and save a moment of laughter with my own mother who, at ninety, is both beautiful and brave.